The Nevada Test Site

The Nevada Test Site

EMMET GOWIN

FOREWORD BY

ROBERT ADAMS

PRINCETON UNIVERSITY PRESS

PRINCETON AND OXFORD

For my friends Robert Adams, Jane Watkins, and Terry Tempest Williams

This publication is made possible in part by a grant from the Barr Ferree Foundation Fund for Publications, Department of Art and Archaeology, Princeton University.

Published by Princeton University Press, 41 William Street, Princeton, New Jersey 08540
In the United Kingdom: Princeton University Press, 6 Oxford Street, Woodstock, Oxfordshire OX20 1TR

press.princeton.edu

Jacket illustrations: (*front*) Emmet Gowin, *Subsidence Craters, Looking Southeast from Area 8, Yucca Flat, Nevada Test Site*, 1996; and
(*back*) Emmet Gowin, *Troop Placement Trenches, Looking East, Area 5, Nevada Test Site*, 1996

William Stafford, "At the Bomb Testing Site" from *Ask Me: 100 Essential Poems*. Copyright © 1960, 2014
by William Stafford and the Estate of William Stafford. Reprinted with the permission of
The Permissions Company, LLC on behalf of Graywolf Press, Minneapolis, Minnesota, www.graywolfpress.org.
Excerpt from "Mass for the Day of St. Thomas Didymus, ii. Gloria" by Denise Levertov, from *Candles in Babylon*, copyright
© 1982 by Denise Levertov. Reprinted by permission of New Directions Publishing Corp. Denise Levertov, *New Selected Poems*
(Bloodaxe Books, 2003) www.bloodaxebooks.com.

Library of Congress Cataloging-in-Publication Data

Names: Gowin, Emmet, 1941– author, photographer. | Adams, Robert, 1937– writer of foreword.
Title: The Nevada Test Site / Emmet Gowin ; foreword by Robert Adams.
Description: Princeton : Princeton University Press, [2019]
Identifiers: LCCN 2019015506 | ISBN 9780691196039 (hardcover)
Subjects: LCSH: Nuclear weapons—United States—Testing—History. | Nevada National Security Site—Pictorial works. |
Nevada National Security Site—History. | Nevada National Security Site—Environmental conditions. |
Landscape photography—Nevada—Miscellanea.
Classification: LCC U264.3 .G69 2019 | DDC 623.4/51190287—dc23 LC record available at https://lccn.loc.gov/2019015506

British Library Cataloging-in-Publication Data is available

Designed and typeset by Katy Homans in Centaur types
Digital separations by Robert J. Hennessey
Printed in Italy by Trifolio

Printed on acid-free paper. ∞

1 3 5 7 9 10 8 6 4 2

Contents

Foreword

ROBERT ADAMS

At the Bomb Testing Site[1]

At noon in the desert a panting lizard
waited for history, its elbows tense,
watching the curve of a particular road
as if something might happen.

It was looking at something farther off
than people could see, an important scene
acted in stone for little selves
at the flute end of consequences.

There was just a continent without much on it
under a sky that never cared less.
Ready for a change, the elbows waited.
The hands gripped hard on the desert.

— William Stafford

After that, what happened? We know, of course, but we still do not know. We are, in our way, as taut as was the creature that Stafford imagined.

Between 1951 and 1992 there were almost a thousand (928) nuclear detonations at the Nevada Test Site. To this day there continue to be subcritical tests there in order to establish that our stockpile of an estimated 6,550 nuclear weapons is at all times ready to use.

Photographers have worked since the early years of the nuclear age to awaken us. In 1955, for example, Edward Steichen created an exhibition and book of pictures titled *The Family of Man*; it reminded us of the value of the life we share and built to this warning by the scientist Bertrand Russell: "The best authorities are unanimous in saying that a war with hydrogen bombs is quite likely to put an end to the human race. . . . There will be universal death—sudden only for the fortunate minority, but for the majority a slow torture of disease and disintegration."

The history of our avoidance of that fate is not reassuring. As synopsized by Eric Schlosser in *Command and Control* (Penguin, 2013), nuclear war has sometimes been averted only at the last minute,

sometimes only by the courage of a few, and sometimes by nothing more than luck. The current potential for a nuclear exchange between the United States and Russia was described this way by California's governor Jerry Brown: "In forty-five minutes it could be over. . . . Human beings in 2018 are living with unimaginable powers of both creativity and utter, final destruction."[2] One tries but cannot imagine the loss of every picture by Rembrandt, of every recording of music by Bach.

We hope that we have learned enough to escape nuclear war, and there have in fact been improvements in the technologies of weapons safety and of communications. The problem that remains, however, is human nature. We now watch with dismay, for example, as the use of poison gas has returned. For almost a century we supposed that we had learned from the horror of its use in World War I. But we are still too selfish to adequately support the world government that would be needed to stop such atrocities. One is reminded of an observation by Flaubert at the outbreak of the Franco-Prussian War: "Whatever happens, we will still be stupid."

Why not give up? Probably the chief reason is in the faces of those we love. Emmet Gowin has elsewhere made unmistakable that he feels this, and it is not fanciful to suppose that he somehow sees his wife, Edith, and their children as present at the Nevada Test Site.

In addition, as a photographer—a person whose profession it is to see with complete attention—Gowin is, I believe, sufficiently astonished by mystery to survive discouragement. He sees that our world is also another world.

As it happened, when I was studying the pictures in the book that do *not* record human-made scarring—why, I wondered, did he include them?—I received in the mail a little package of stones. It was sent by a friend who had spent years photographing hardships throughout the world, but who now wrote to say that he had moved to a remote location at the edge of the Great Basin, that he loved it there, and that he was preparing a photo essay about his new home. He added that currently he alternated between being a photographer and being a "rock hound," and that the package contained petrified wood, a day's pleasure.

His letter and gift reminded me of how often I had recovered from photographing in desolate new suburbs by finding a vacant lot where, for a few minutes, I could scuff up gravel, saved by the beauty of small geologic reminders.

Similarly, I think Gowin kept photographing when the helicopter turned him away from the human-made scars because he saw that the truth of this other landscape would outlast us. The mountains, alluvial fans … every nameless arroyo … recalled for him what we could not harm.

Gowin's calling is, thankfully, to see wide.

He was given permission to photograph over the Nevada Test Site, he tells us, because of some good luck, but much more amazing, I think, is that the opportunity came to a person with just the right combination of discipline, technical expertise, aesthetic good judgment, moral compulsion, and spiritual maturity needed to make of it something redemptive.

Denise Levertov wrote lines consonant with the book:

> Praise
> god or the gods, the unknown,
> that which imagined us, which stays
> our hand,
> our murderous hand,
> and gives us
>
> still,
> in the shadow of death,
> our daily life,
> and the dream still
> of goodwill, of peace on earth.[3]

1. The poem by William Stafford appears in *Stories That Could Be True: New and Collected Poems*, Harper and Row, 1977.
2. Brown is quoted in "California v. Trump" by Connie Bruck in *The New Yorker*, March 26, 2018, 38.
3. From "Gloria" segment of "Mass for the Day of St. Thomas Didymus" in *Candles in Babylon* (New York: New Directions, 1982).

Plates

PLATE 1

HIDDEN SHADOWS AND BRAIDED ARROYOS, SOUTH OF FRENCHMAN FLAT, NEVADA TEST SITE, 1996

NOTE: GPS locations are given for most photographs to approximately identify the camera position
when the image was made, although the elevation involved must be understood intuitively.

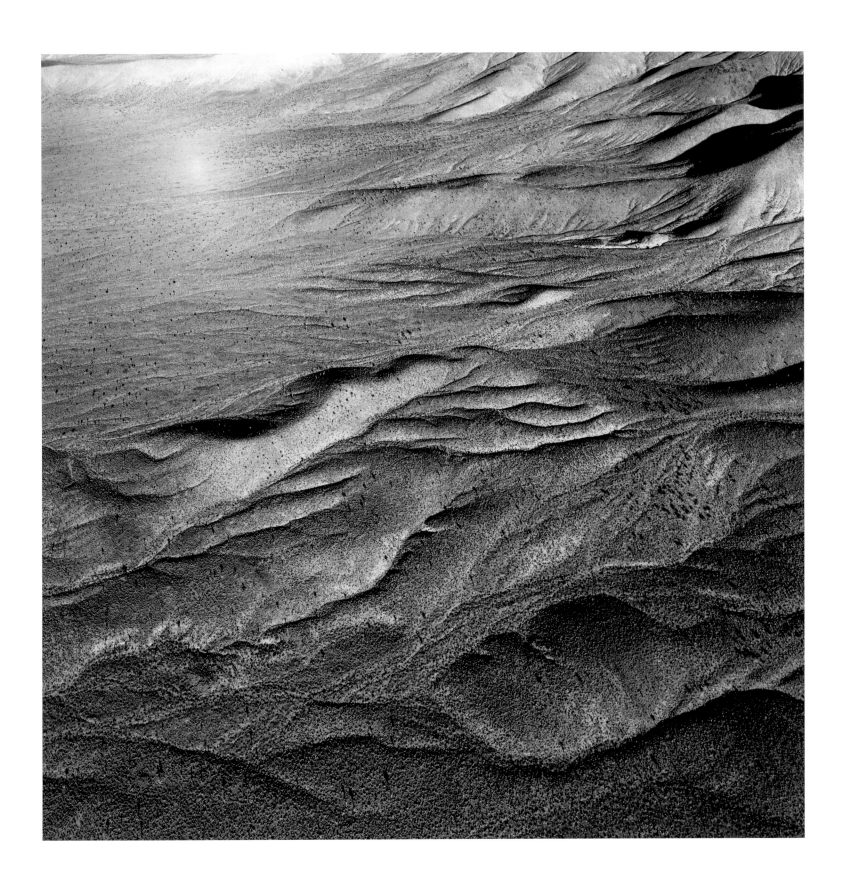

PLATE 2

UNIDENTIFIED RANGE, LOOKING NORTH, WEST OF YUCCA FLAT, NEVADA TEST SITE, 1996

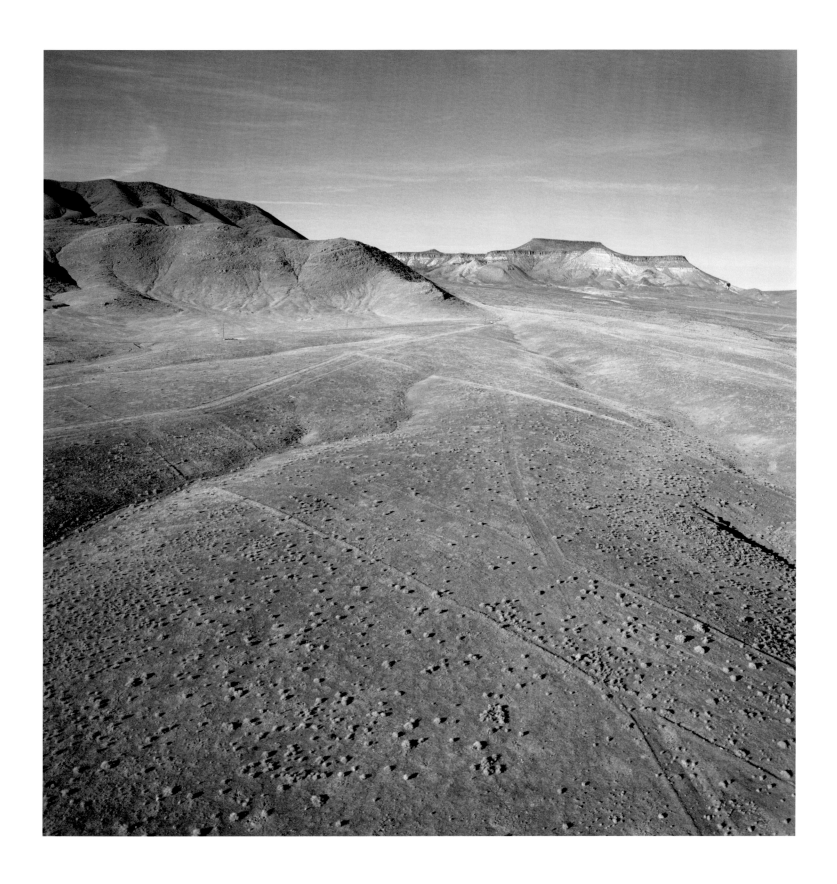

PLATE 3

APPROACHING WINTER STORM, LOOKING WEST TOWARD TONOPAH FROM THE DESERT ROCK AIRSTRIP,
NEVADA TEST SITE, 1997

36°38'40.78" N 116°1'44.25" W

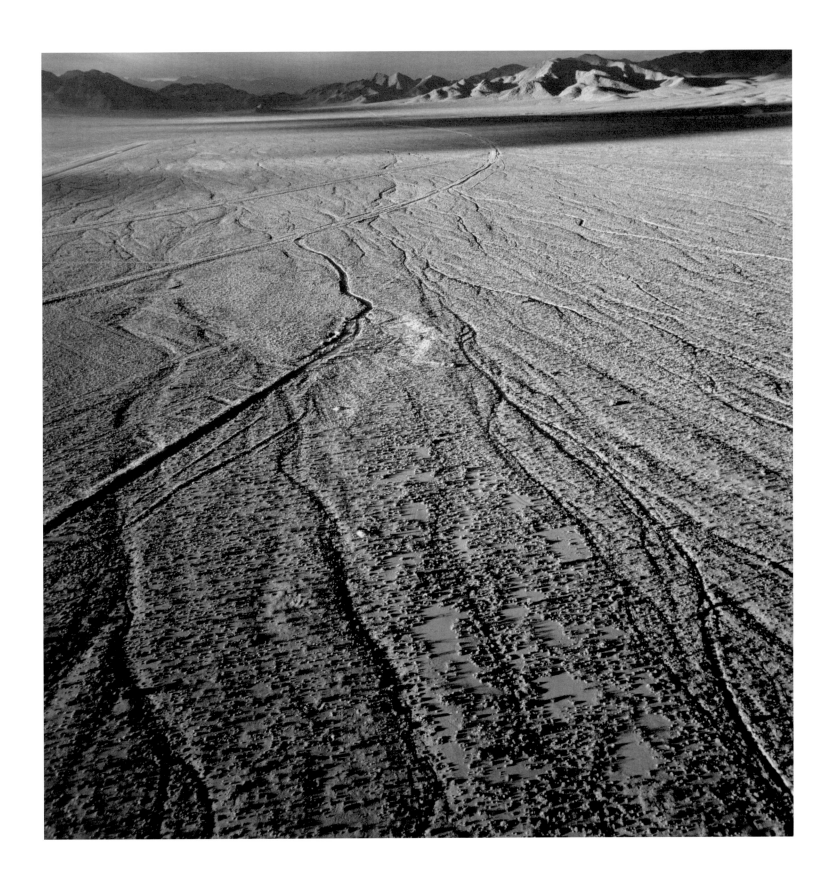

PLATE 4

SUBSIDENCE CRATERS, LOOKING SOUTHEAST FROM AREA 8, YUCCA FLAT, NEVADA TEST SITE, 1996

In the near center is the subsidence crater of Portmanteau, August 30, 1974, and on its right, Portulaca, June 28, 1973, both 200-kiloton tests. Almost touching Portmanteau is Liptauer, a 150-kiloton test, conducted April 3, 1980.

37°9'20.56" N 116°5'13.52" W

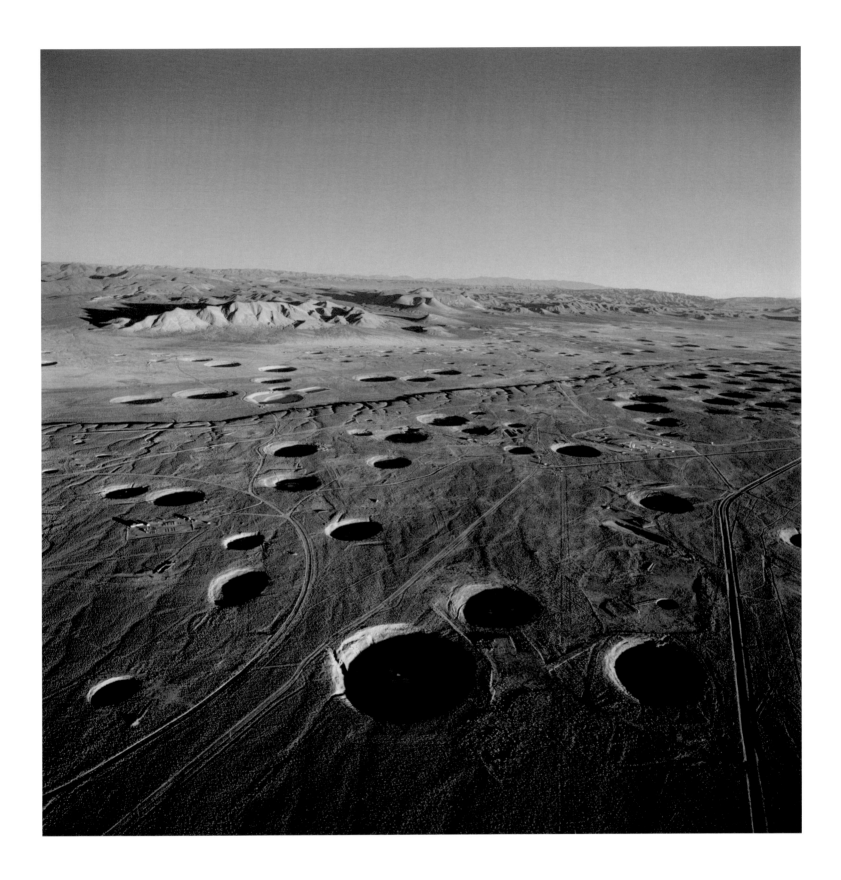

PLATE 5

LEAVING A HELICOPTER LANDING SITE ALONG THE RAINIER MESA ROAD,
NORTHWEST OF SEDAN CRATER, NEVADA TEST SITE, 1996

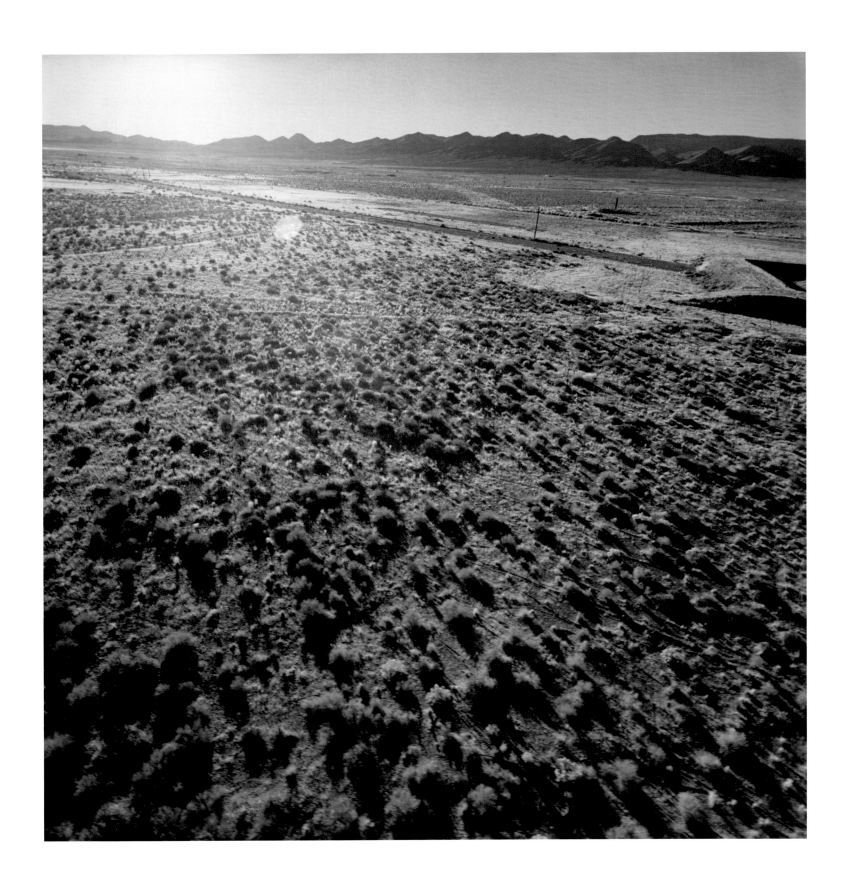

CENTER OF YUCCA FLAT, PERIMETER SECURITY CIRCLES WITH SUBSIDENCE CRATERS,
LOOKING NORTHEAST, AREA 9, NEVADA TEST SITE, 1996

In the near center is the site of Potrillo, a 200-kiloton weapons-related shaft test conducted June 21, 1973;
on the right is the site of the atmospheric test Easy, part of Operation Buster, a 31-kiloton airdrop test, conducted November 5, 1951.

37°5'17.35" N 116°1'49.54" W

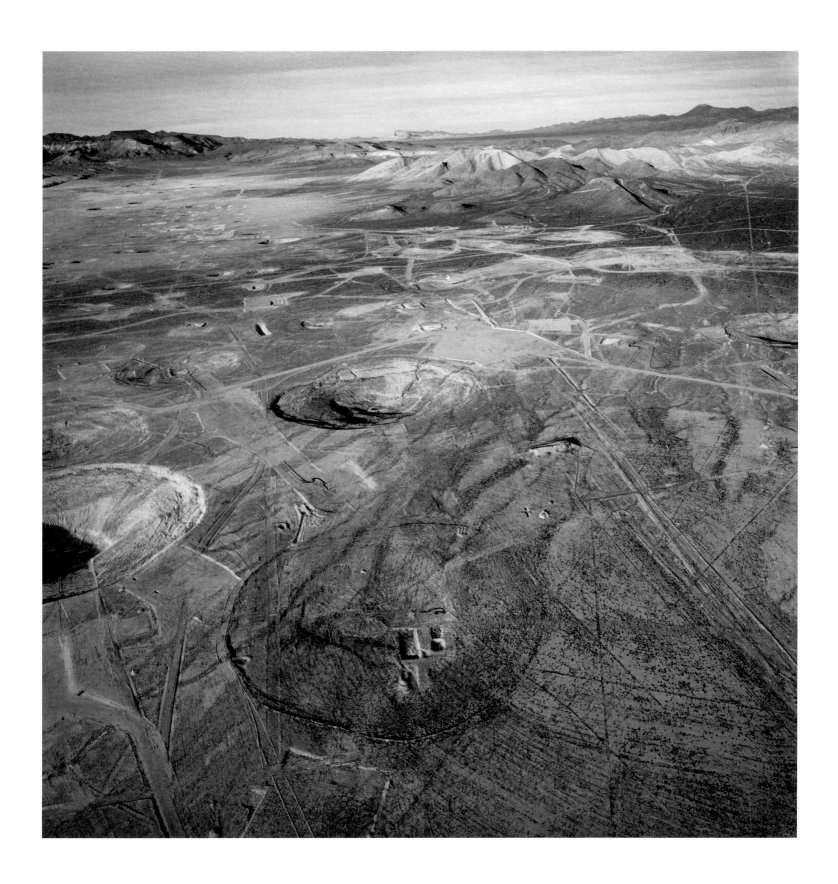

PLATE 7

YUCCA FLAT, THE LARGE CIRCLE ROAD, LOOKING NORTH, AREA 2, NEVADA TEST SITE, 1996

A prominent feature of Yucca flat, the large circle road contains over twenty underground nuclear tests with at least seventeen subsidence craters visible. In the foreground and just outside the circle are three subsidence craters: Portmanteau, August 30, 1974, a 200-kiloton test; Par, October 9, 1964, a 38-kiloton test; Kloster, February 15, 1979, a 150-kiloton test.

37°8'52.03" N 116°4'38.94" W

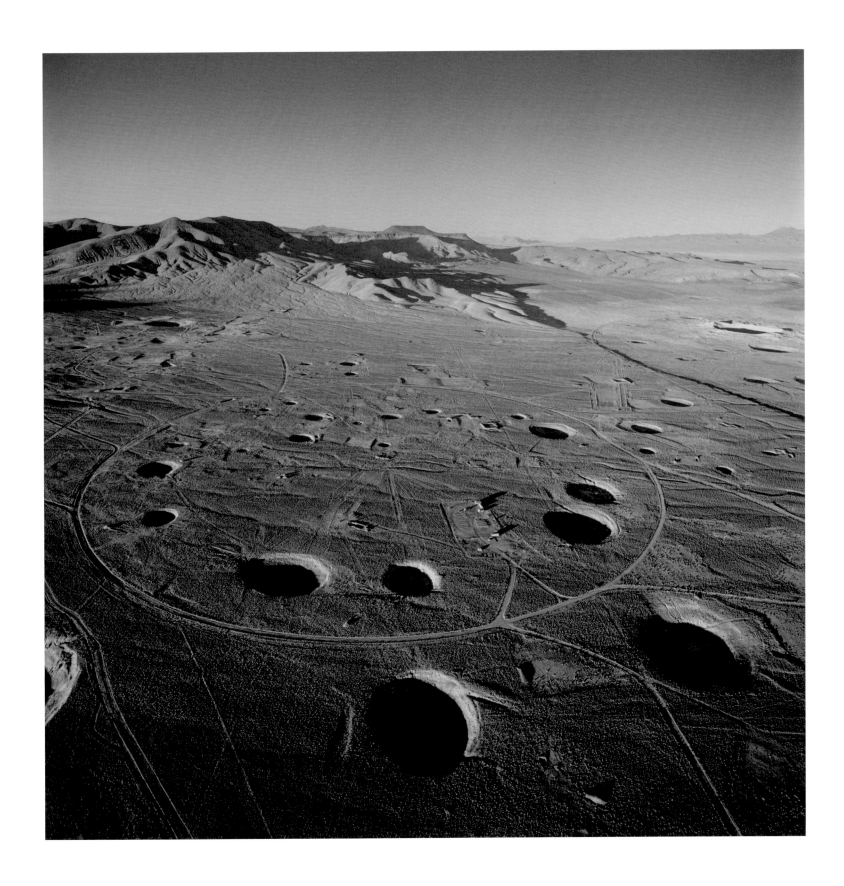

YUCCA FLAT, LOOKING NORTH, ON THE EAST SIDE OF AREA 7, NEVADA TEST SITE, 1996

The sharp-edged crater is Burbon, conducted January 20, 1967; less visible but directly above are the tests Fahida, conducted May 26, 1983; Aligote, conducted May 28, 1981; and to the left, the large subsidence crater is Artesia, with a yield of 45 kilotons, December 16, 1970.

37°5'40.44" N 116°0'17.86" W

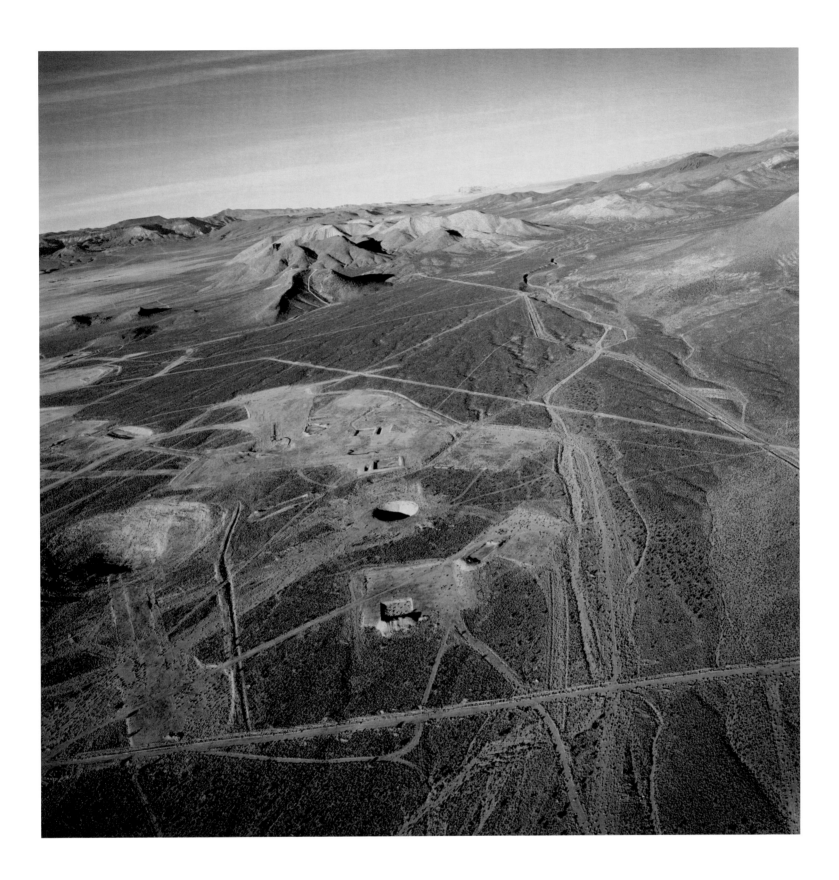

FAULT LINE AND LINE OF SIGHT MARKINGS AT THE SOUTHEAST EDGE OF FRENCHMAN FLAT,
LOOKING SOUTHWEST, NEVADA TEST SITE, 1997

36°47'56.43" N 115°54'10.08" W

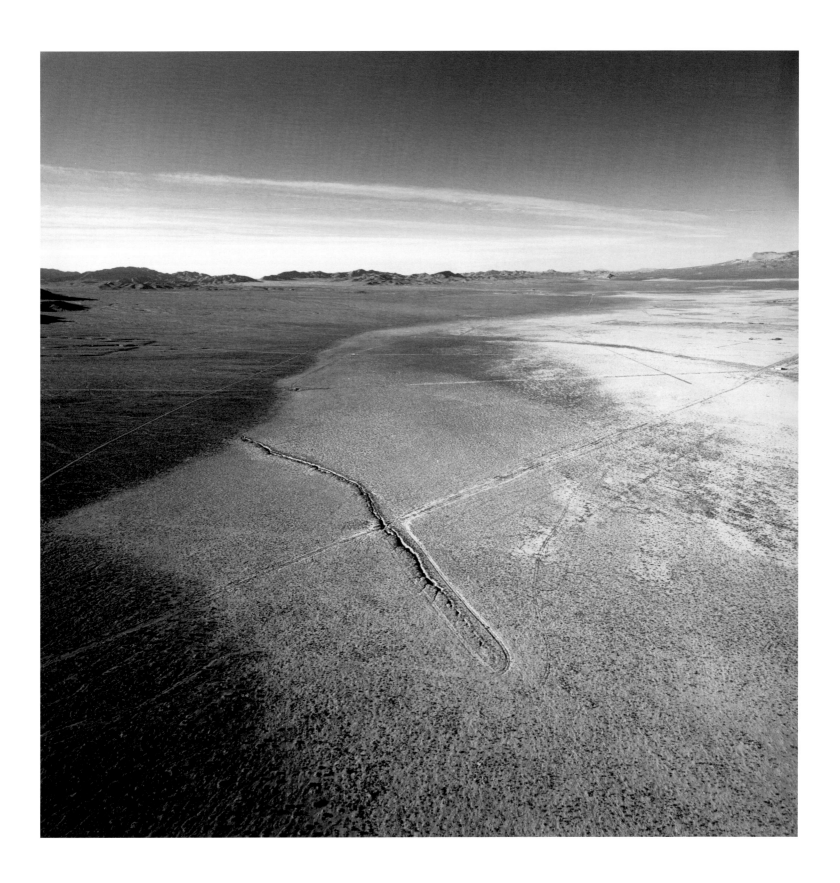

PLATE 10

TROOP PLACEMENT TRENCHES, LOOKING SOUTHEAST, AREA 5, NEVADA TEST SITE, 1997

36°43'3.55" N 115°58'8.96" W

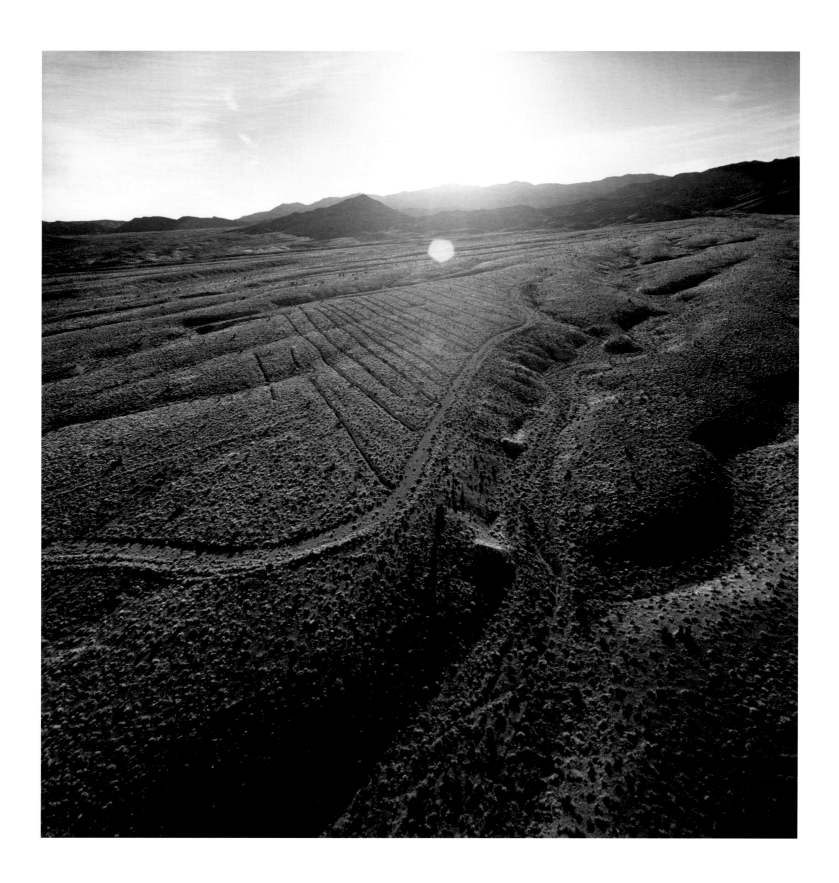

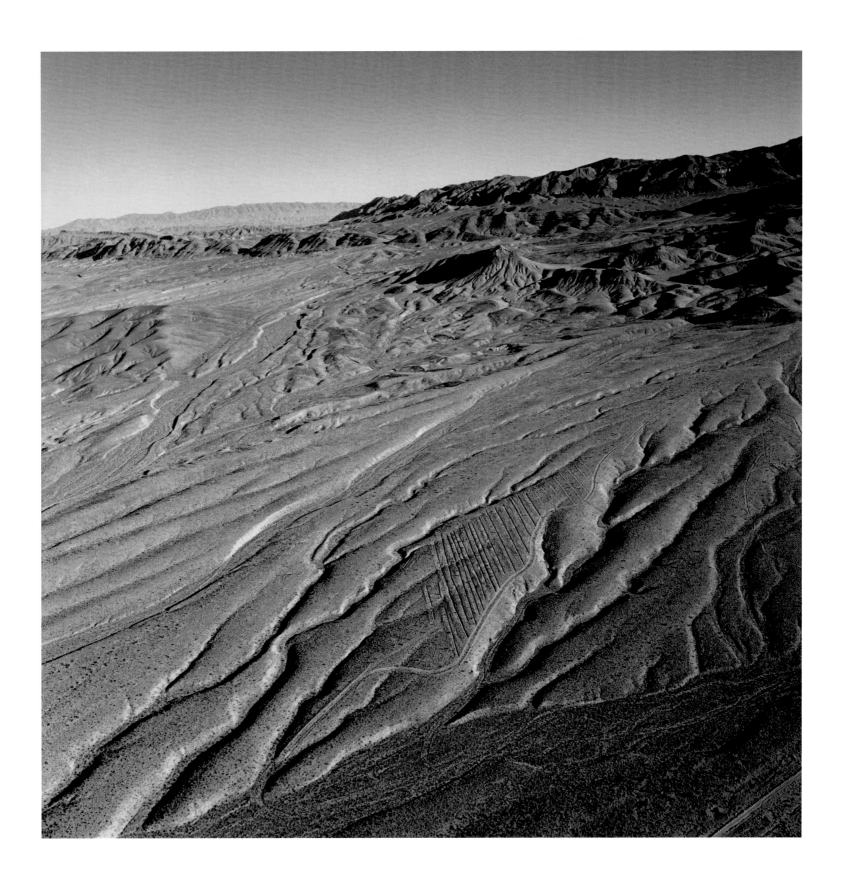

PLATE 12

SUBSIDENCE CRATER, TAJO, LOOKING NORTHEAST, AREA 9, NEVADA TEST SITE, 1996

Part of Operation Charioteer, Tajo was a 150-kiloton weapons-related shaft test, June 5, 1986.

$37°5'45.85"$ N $116°1'12.13"$ W

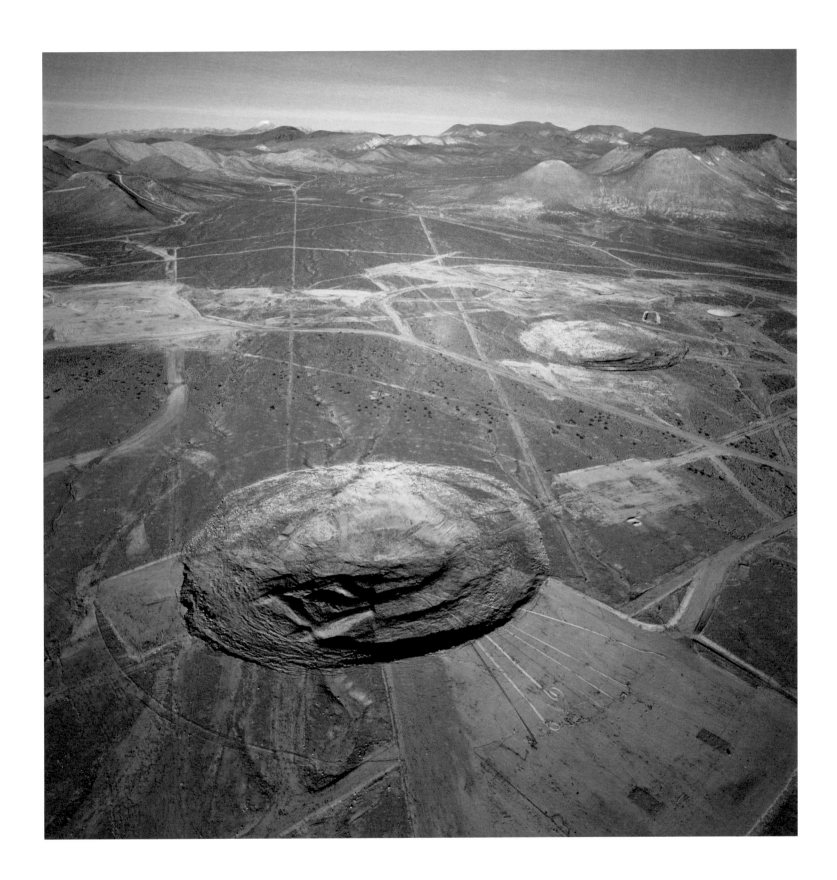

THE CENTER OF YUCCA FLAT, LOOKING NORTHEAST PAST A LARGE CIRCLE SECURITY FENCE WITH
SUBSIDENCE CRATERS IN THE DISTANCE, AREA 9, NEVADA TEST SITE, 1996

Approximate site of the airdrop atmospheric test Easy. There were at least four tests with the code name Easy.
This test, with a yield of 31 kilotons, was part of Operation Buster, November 5, 1951.

37°5'8.97" N 116°1'39.96" W

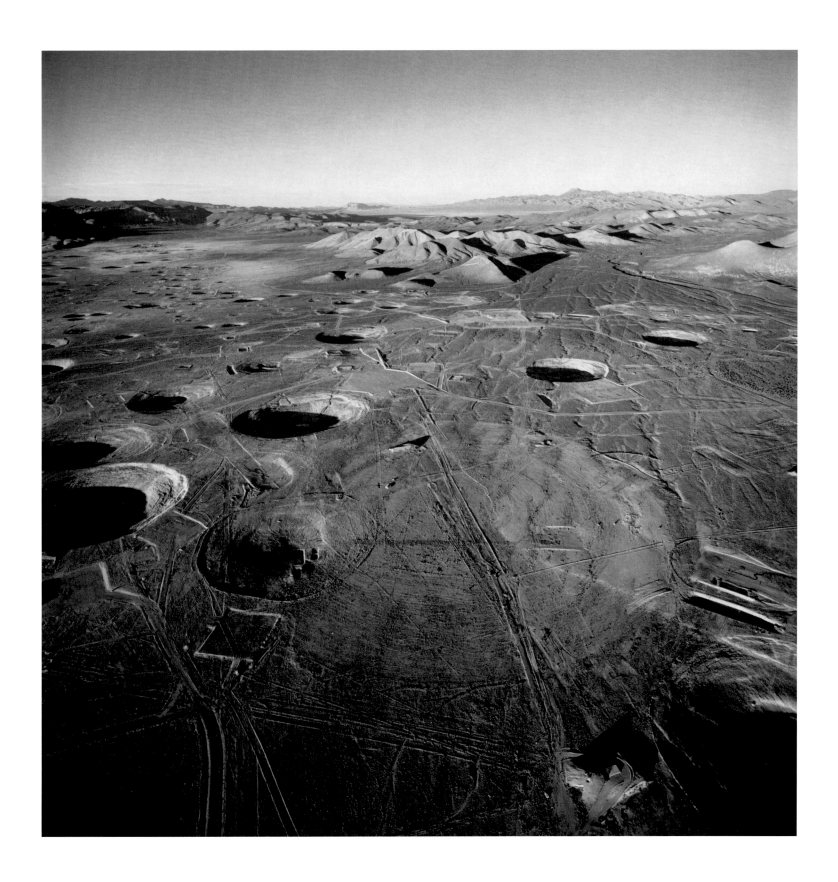

THE EASTERN EDGE OF FRENCHMAN FLAT SHOWING THE TRANSITION FROM ALLUVIAL WASH
TO DRY LAKE BED, LOOKING EAST, AREA 5, NEVADA TEST SITE, 1997

36°46'58.52" N 115°55'4.89" W

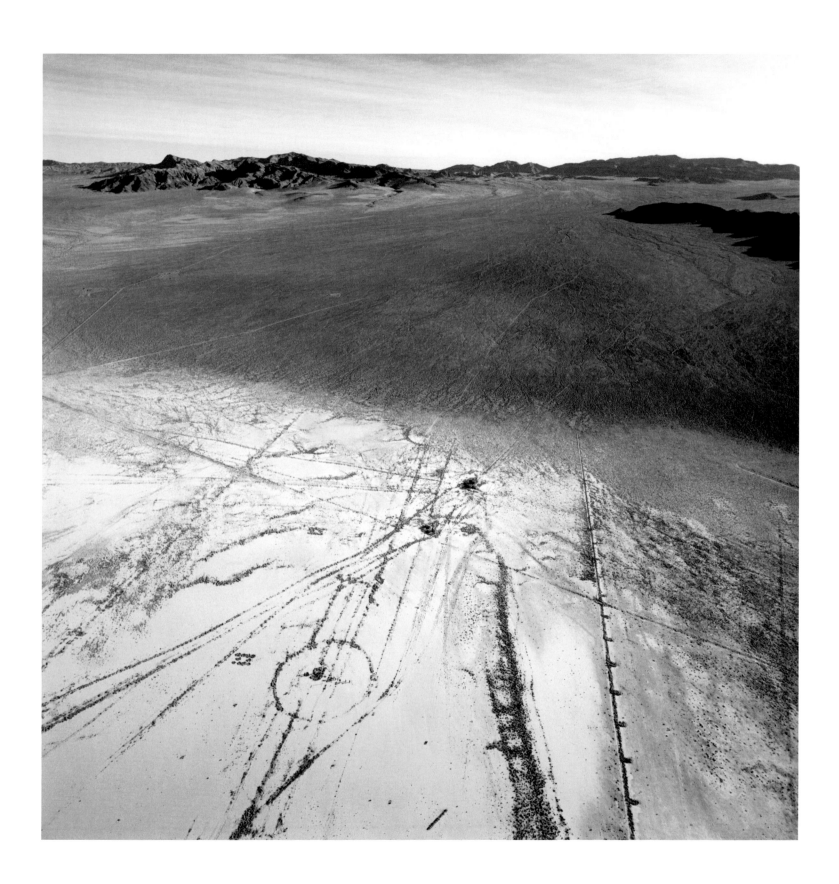

PLATE 15

PERIMETER FENCES, DRILL SLURRY POND BOXES, AND THE CRATER KANKAKEE,
NORTHERN END OF YUCCA FLAT, LOOKING SOUTHEAST, AREA 10, NEVADA TEST SITE, 1996

Kankakee, a 200-kiloton weapons-related shaft test, was part of Operation Flintlock, conducted June 15, 1966.
The Banded Mountains are in the distance.

37°10'22.97" N 116°03'03.91" W

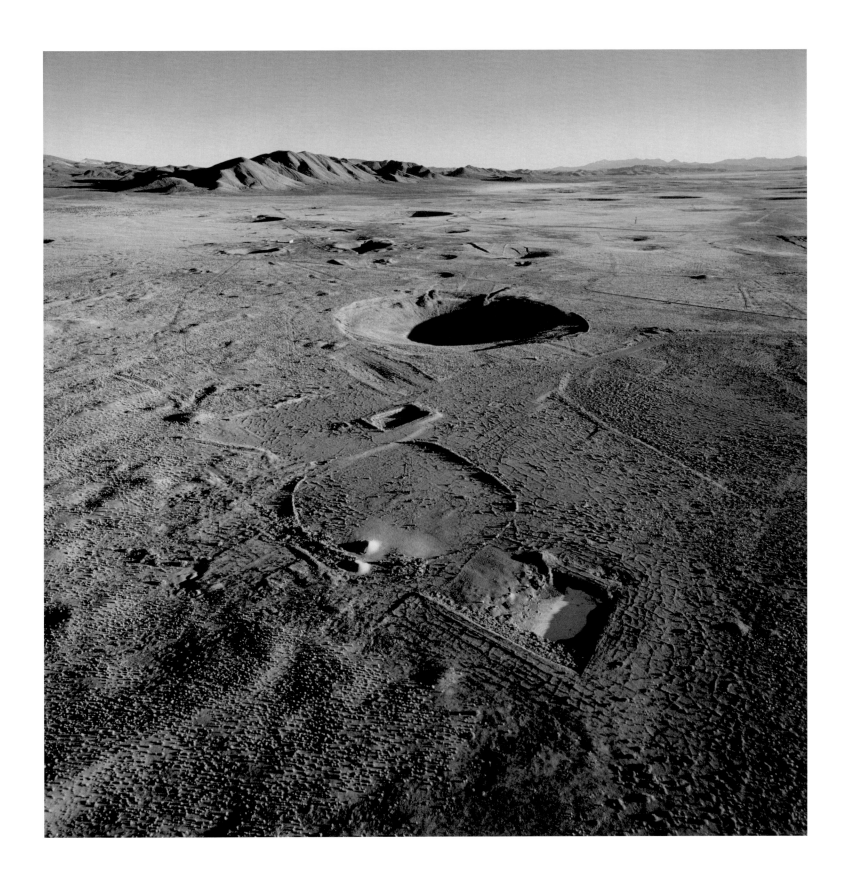

PLATE 16

**PERIMETER FENCES, DRILL SLURRY POND BOXES, AND SUBSIDENCE CRATERS,
NEAR THE CENTER OF YUCCA FLAT, LOOKING WEST, AREA 7, NEVADA TEST SITE, 1996**

From near to far the tests were Marsh, September 6, 1975; Seyval, November 12, 1982; Huron King, June 24, 1980; and Puye, August 14, 1974. Each had an approximately 20-kiloton yield, similar to the force of the Nagasaki bomb. Slightly to the left of this line of four tests is Barsac, with a yield of 10 kilotons, March 20, 1969.

37°1'26.49" N 116°1'34.59" W

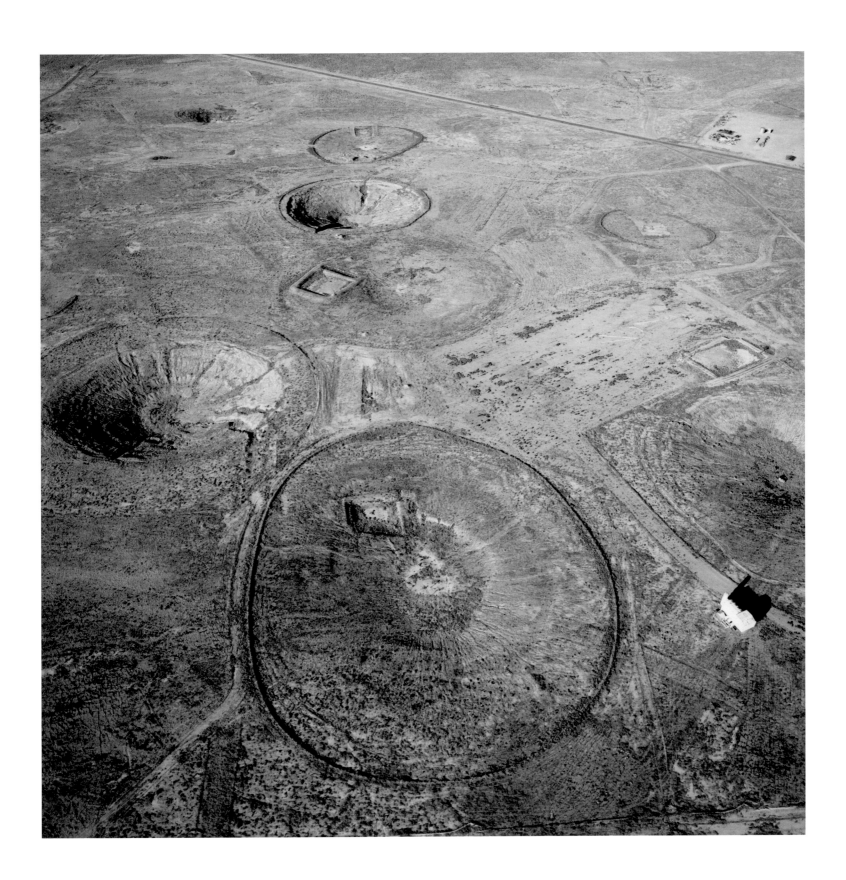

PLATE 17

YUCCA FLAT, COMPLEX ROADS AND SUBSIDENCE CRATERS CROSSED BY LINES OF SIGHT,
LOOKING NORTHEAST, AREA 7, NEVADA TEST SITE, 1996

Tests conducted here include Dutchess, October 24, 1980; Texarkana, February 10, 1989; Mickey, May 10, 1967; and Torrido, May 27, 1969.

37°4'8.14" N 116°0'4.32" W

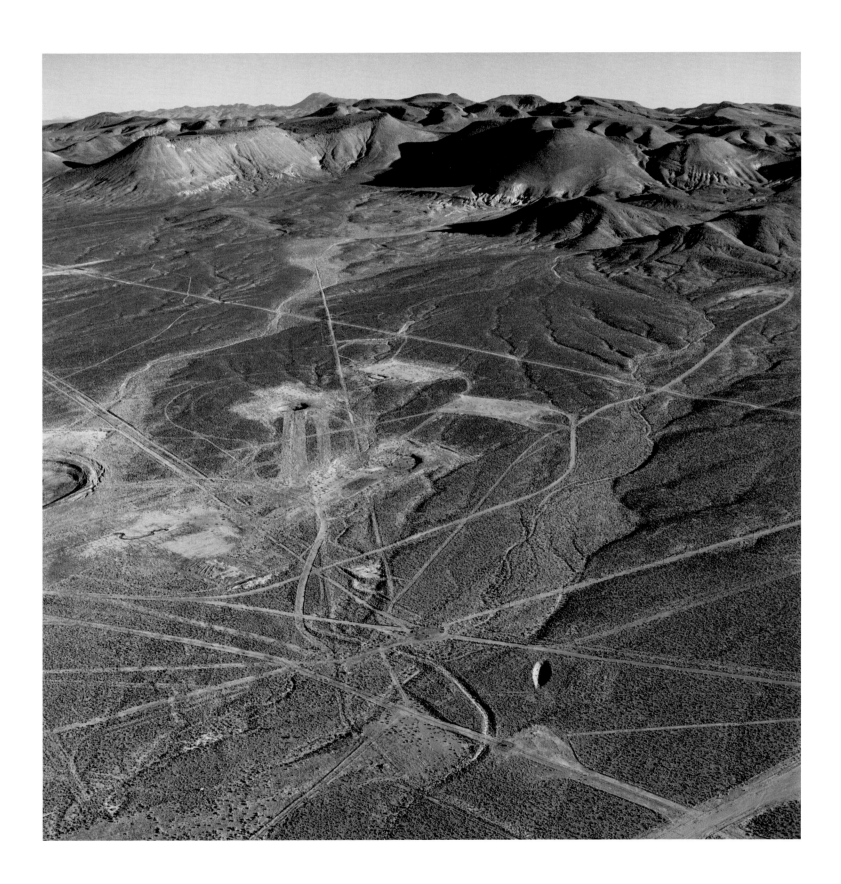

PLATE 18

TOWER AND DIAGNOSTIC ARRAY FOR THE US/UK TEST ICECAP, SUSPENDED 1992,
NEVADA TEST SITE, 1996

The Icecap test was to be a joint underground test cosponsored by the United Kingdom and the United States.
The Icecap site is unique in that the tower for shaft drilling and device assembly remains in place, along with trailers and
fiber-optic cables. The three largest craters are Lowball, July 12, 1978, 150 kilotons; Oscuro, September 21, 1972, 160 kilotons;
and Piranha, May 13, 1966, 120 kilotons.

37°4'42.80" N 116°2'53.23" W

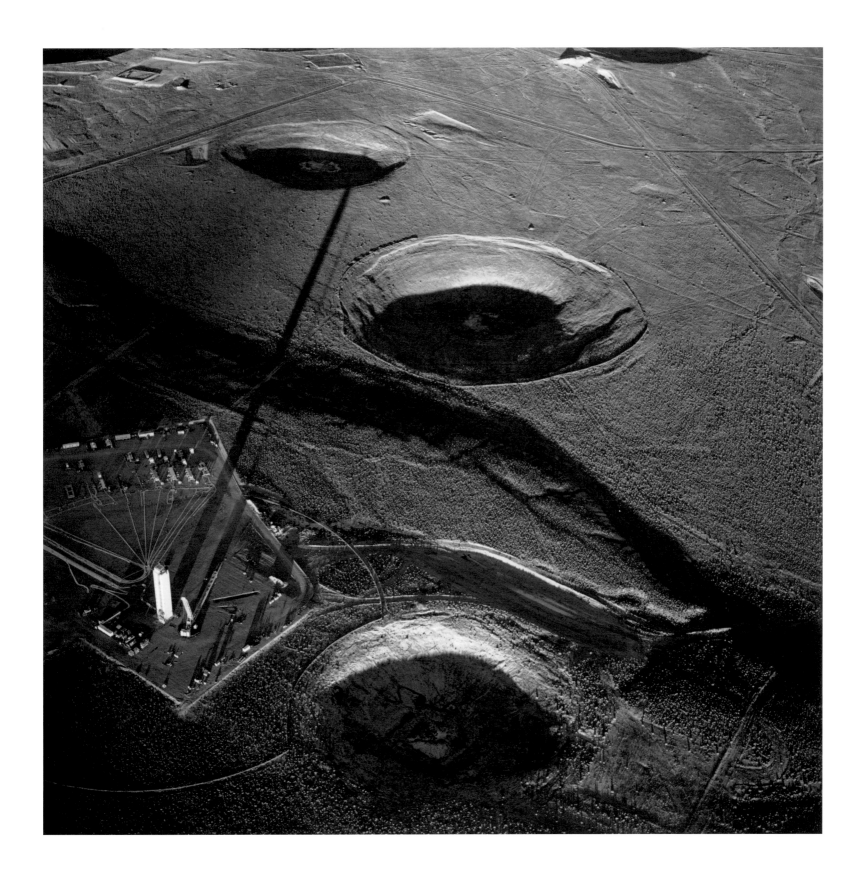

THE MERCURY HIGHWAY BENDING AROUND THE SUBSIDENCE CRATER OF THE AVENS-CREAM TEST, LOOKING TOWARD THE SOUTHERN HALF OF YUCCA FLAT AND YUCCA LAKE, AREA 7, NEVADA TEST SITE, 1996

The Avens-Cream test was one part of a simultaneous weapons test consisting of four devices. The Department of Energy notes an "accidental release of radioactivity detected on site only." All four tests were a part of Operation Emery, December 16, 1970.

37°8'56.97" N 116°1'55.04" W

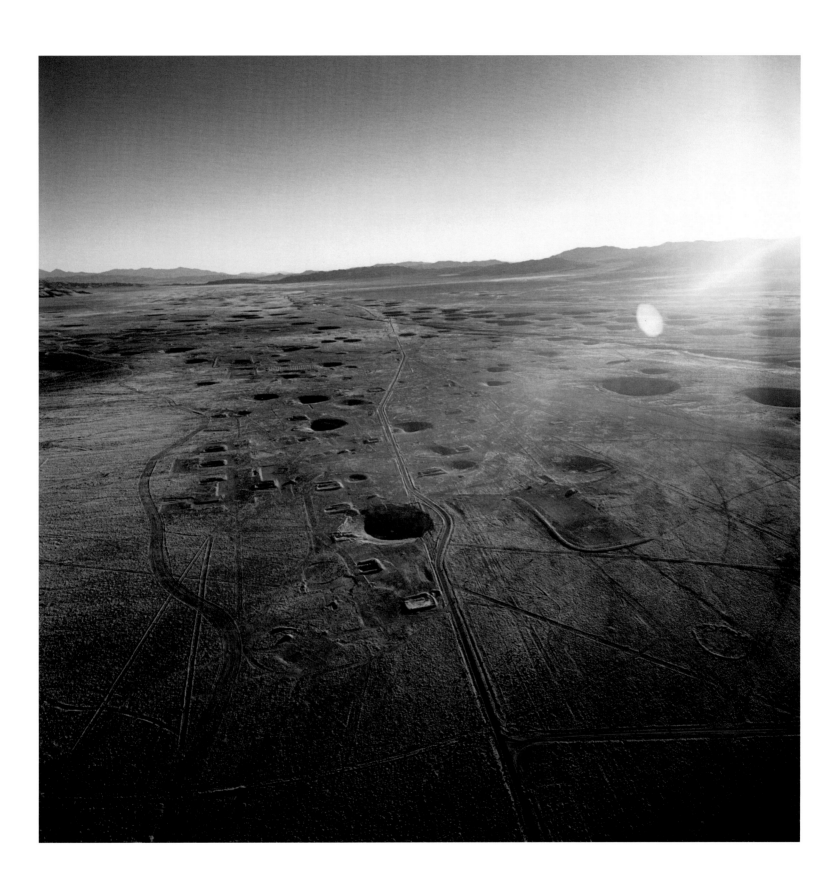

PLATE 20

YUCCA FLAT, THE BILBY CRATER, A 249-KILOTON WEAPONS-RELATED TEST, LOOKING EAST,
AREA 3, SEPTEMBER 13, 1963, NEVADA TEST SITE, 1997

The Department of Energy lists Bilby as the first underground test for which the tremor or shock was felt in Las Vegas.

37°3'39.02" N 116°1'35.74" W

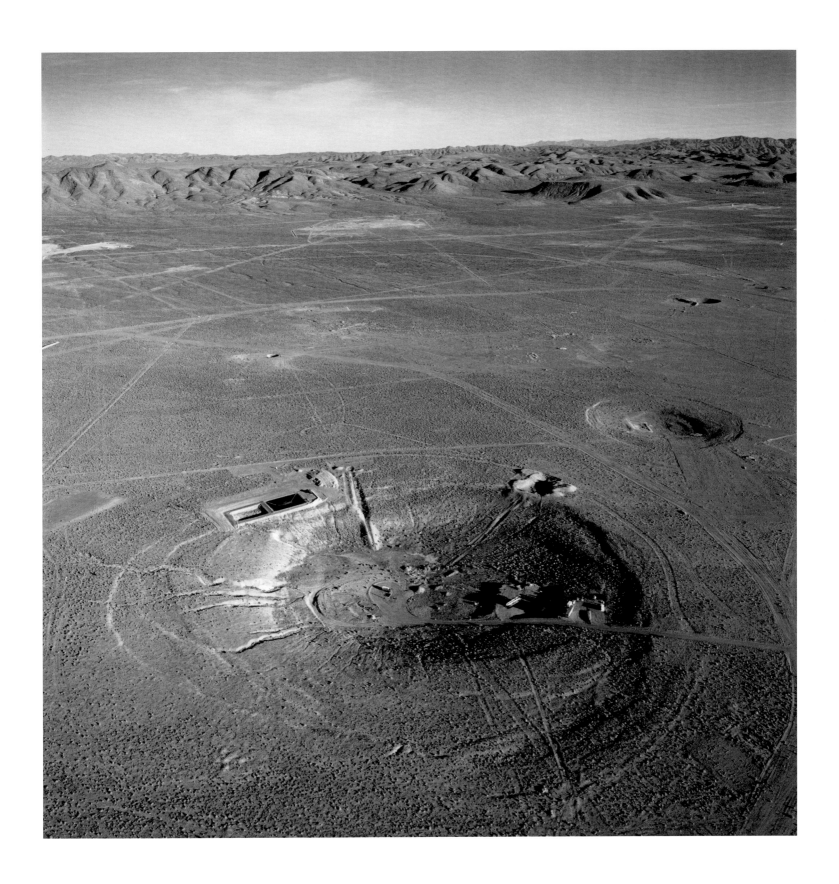

PLATE 21

FIBER-OPTIC CABLE, SUBSIDENCE CRATER, AND THE SITE OF THE SNUBBER TEST,
LOOKING SOUTH ALONG THE EASTERN EDGE OF YUCCA FLAT, AREA 3, NEVADA TEST SITE, 1996

Snubber was an underground shaft weapons-related test, part of Operation Mandrel.
Snubber had a yield of 13 kilotons and was conducted April 21, 1970.

$37°3'41.32"$ N $115°59'16.84"$ W

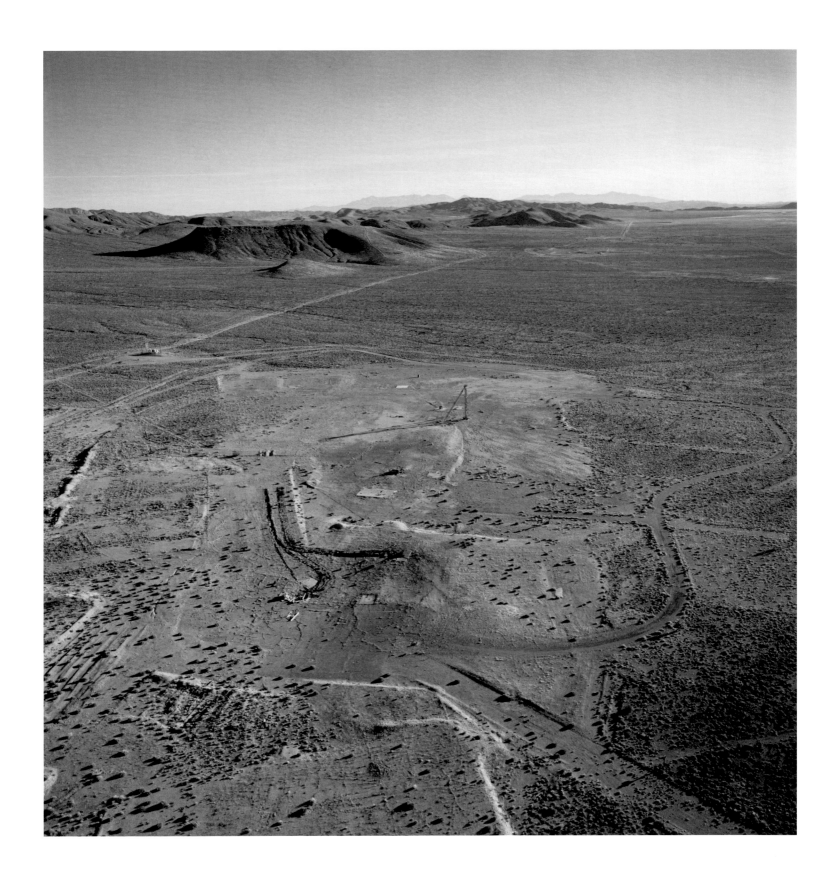

PLATE 22

SUBSIDENCE CRATERS OF SIX UNDERGROUND TESTS INCLUDING ARMADA, DAUPHIN, CEBRERO, TELEME, KESTI, AND LEYDEN; LOOKING NORTH, YUCCA FLAT, AREA 7, NEVADA TEST SITE, 1996

37°6'26.47" N 116°1'5.85" W

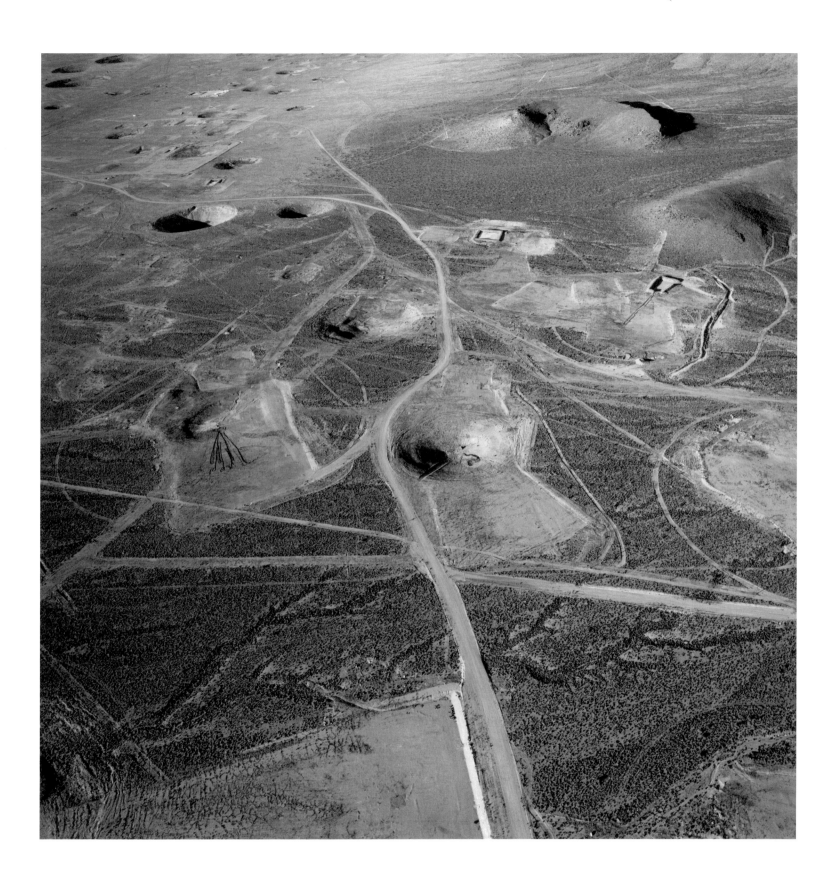

SEVERAL ROADS AND FIVE SUBSIDENCE CRATERS NORTH OF THE RADIOACTIVE WASTE
MANAGEMENT SITE, EASTERN SIDE OF AREA 5, NEVADA TEST SITE, 1997

The five tests conducted here were New Point, December 13, 1966; Diagonal Line, November 24, 1971; Dana Moon, August 27, 1968;
Minute Steak, September 12, 1969; and Milk Shake, March 25, 1968.

36°52'3.59" N 115°56'59.83" W

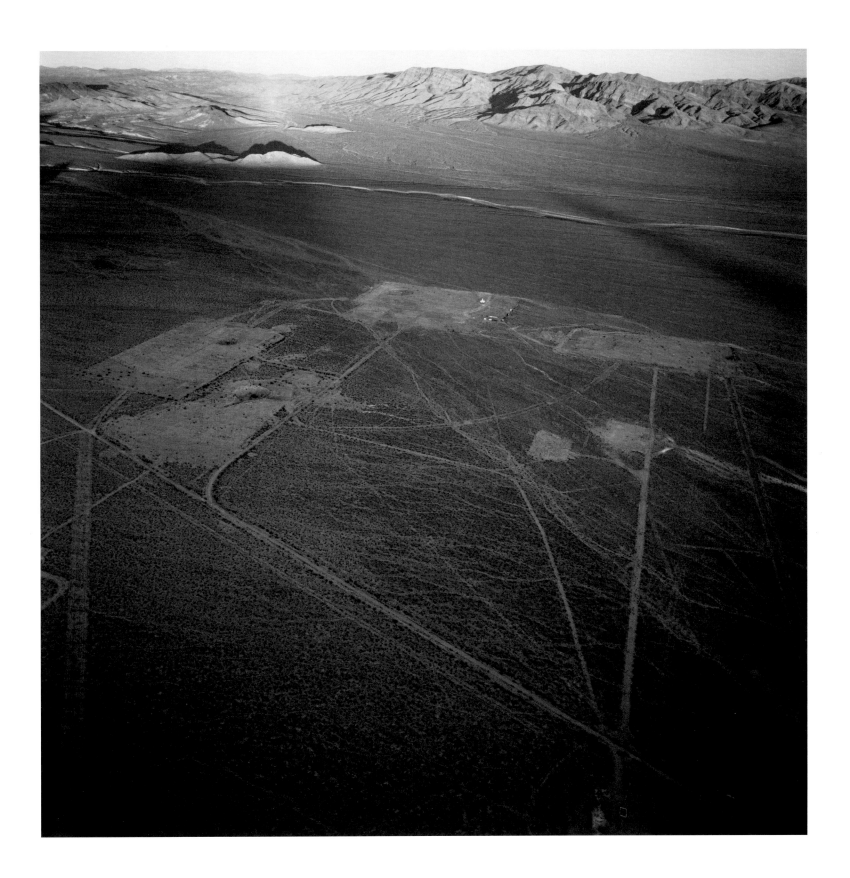

PLATE 24

NUCLEAR TEST SUBSIDENCE CRATERS WITH THE TIPPIPAH HIGHWAY IN THE FOREGROUND, YUCCA FLAT, LOOKING EAST, AREA 2, NEVADA TEST SITE, 1967

The most obvious craters are, from left to right, the Nash test, January 19, 1967, yielding 39 kilotons; the Stutz test, April 6, 1966; and the Pod-D SS test, October 29, 1969, a four-part simultaneous test, all conducted within the circle road, and with accidental release of radioactivity "detected off-site by aircraft only."

37°8'27.74" N 116°8'56.17" W

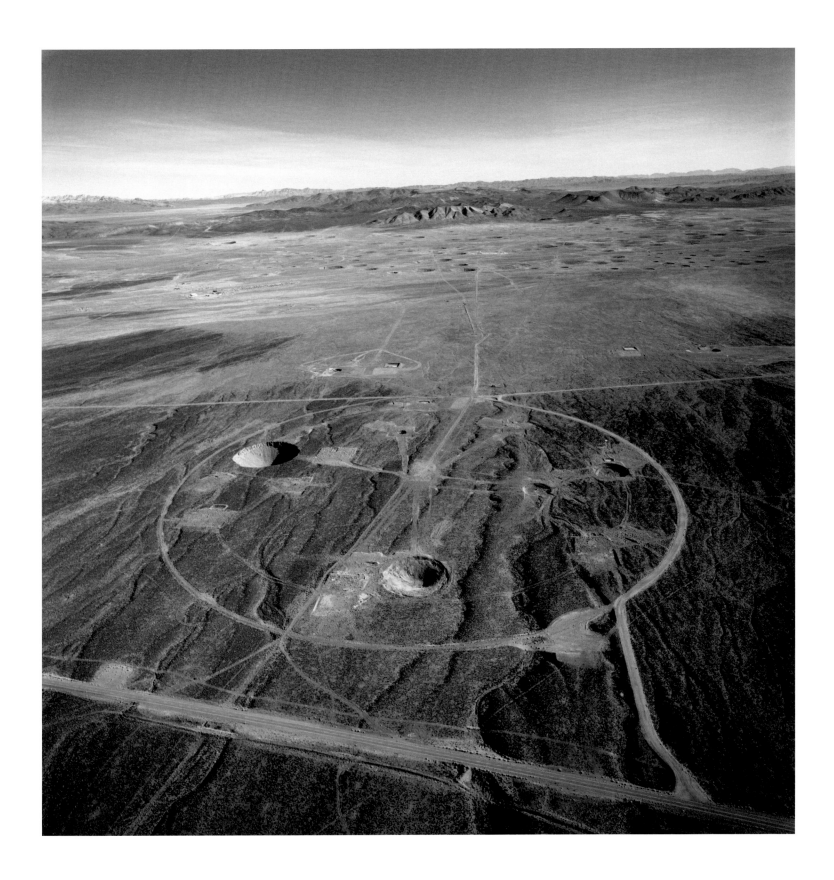

SEDAN CRATER, NORTHERN END OF YUCCA FLAT LOOKING SOUTH, AREA 10, NEVADA TEST SITE, 1996

37°10'53.28" N 116°3'14.86" W

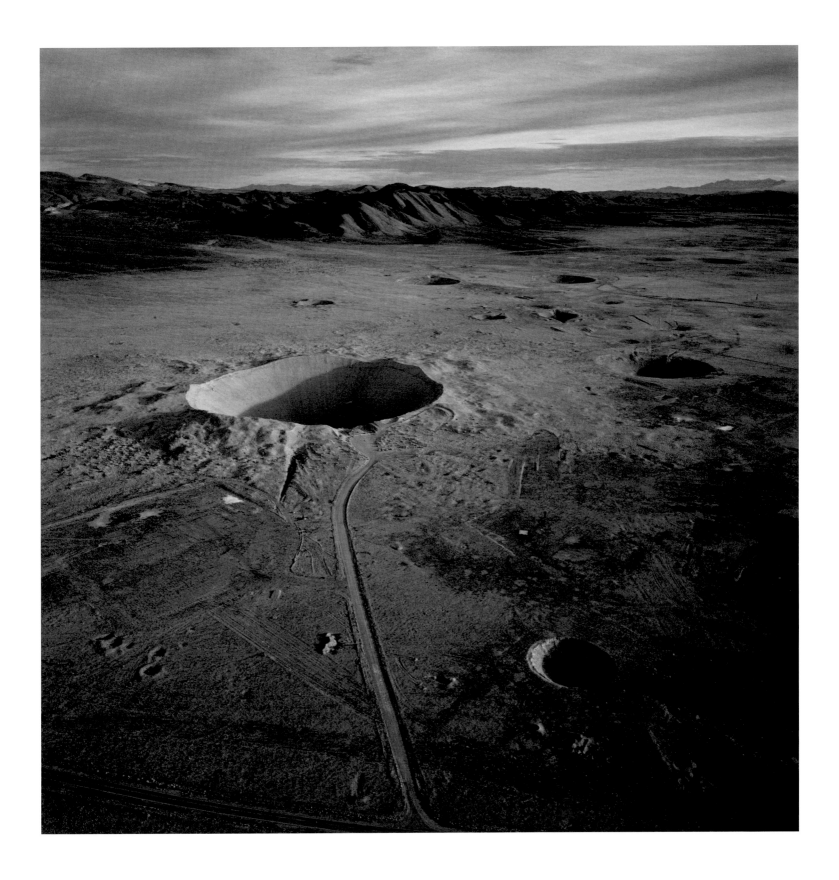

GEOLOGICAL FAULT IN YUCCA LAKE, NORMALLY A DRY LAKE,
SURROUNDED BY AN EXPERIMENTAL DIKE, LOOKING SOUTHWEST, NEVADA TEST SITE, 1996

37°56'8.83" N 116°0'52.49" W

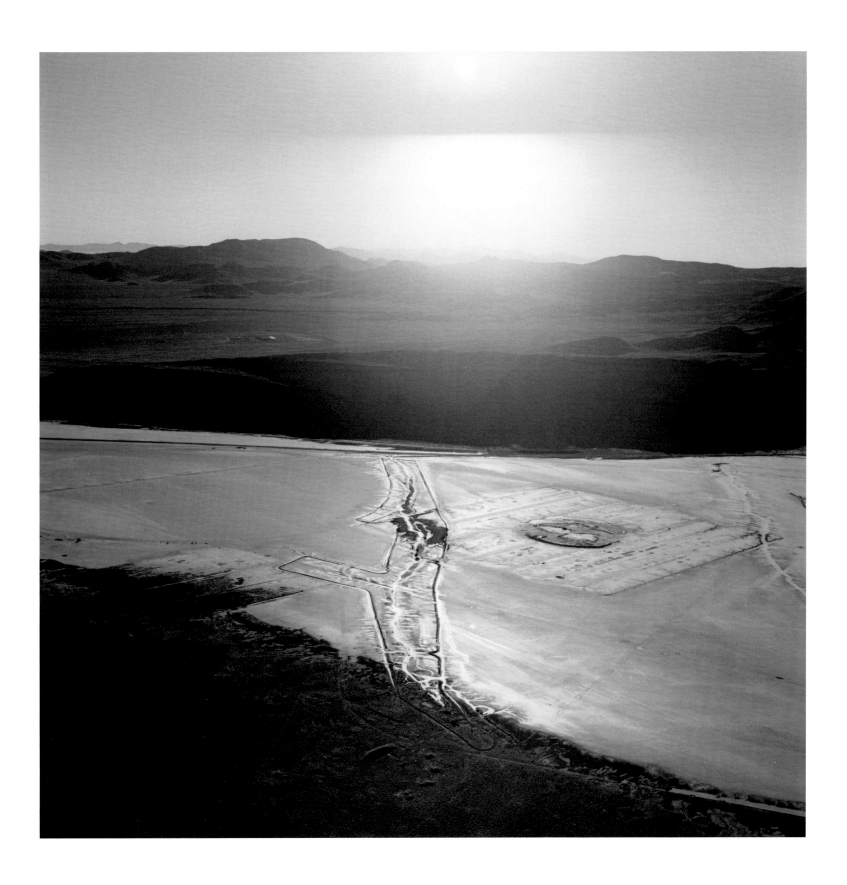

SUBSIDENCE CRATERS, YUCCA FLAT, LOOKING SOUTH, NORTHERN END OF AREA 10,
NEVADA TEST SITE, 1996

The crater with opposing points is Ess, the seventh test in Operation Teapot, conducted March 23, 1955.
Uncle, left, was conducted November 29, 1951, and Ward, near right, was conducted February 8, 1967.

37°10'19.73" N 116°2'51.42" W

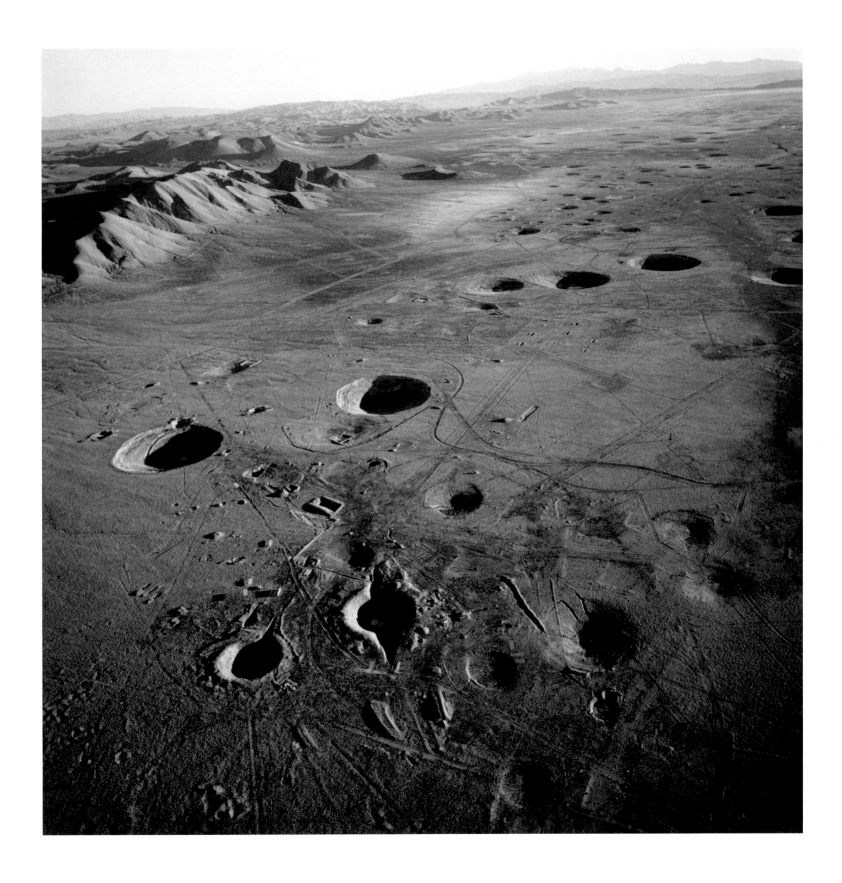

PLATE 28

**VIEW FROM THE CENTER OF YUCCA FLAT, LOOKING SOUTH, AREAS 9, 7, AND 3,
NEVADA TEST SITE, 1996**

The two nearest craters are Pike, March 13, 1964, 2 kilotons, with accidental release of radioactivity detected off-site;
and Gundi Prime, May 9, 1963, a weapons-related test with a low yield.

$37°3'10.83"$ N $116°0'46.99"$ W

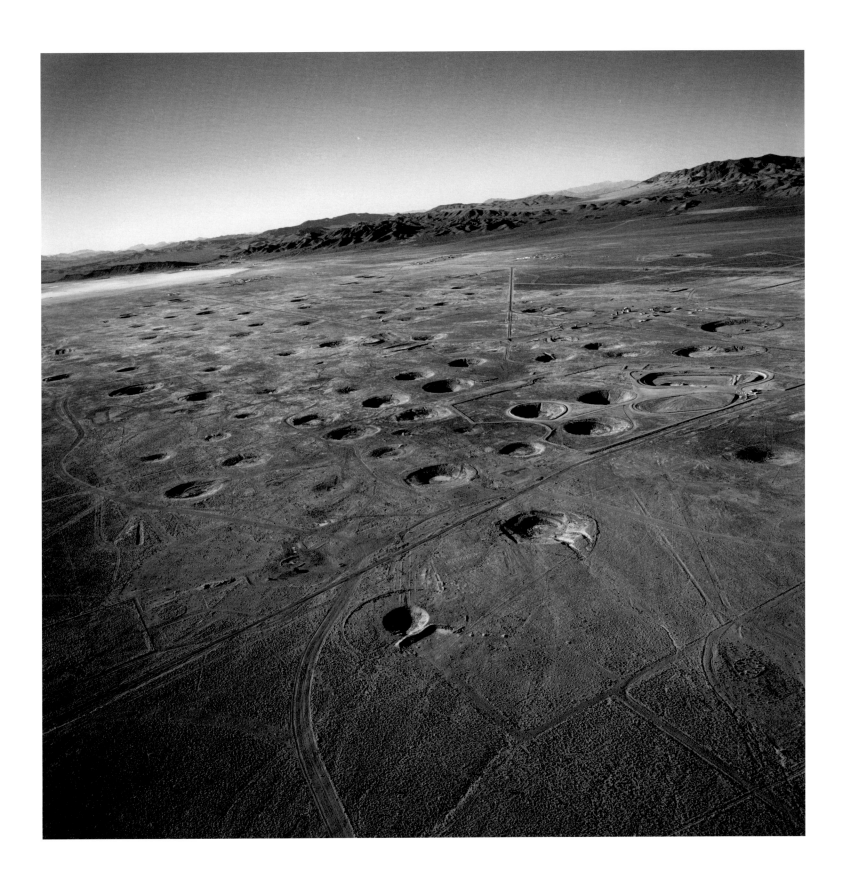

SITE OF THE ATMOSPHERIC TEST SMOKY, YUCCA FLAT,
LOOKING SOUTHEAST FROM THE SOUTHERN END OF AREA 8, NEVADA TEST SITE, 1997

A tower test with a yield of 44 kilotons, Smoky was conducted August 31, 1957. The approximately 700 troops involved in ground maneuvers associated with Smoky were later proven to have been severely irradiated. This area is reportedly considered contaminated and is still avoided.

37°11'14.36" N 116°4'19.62" W

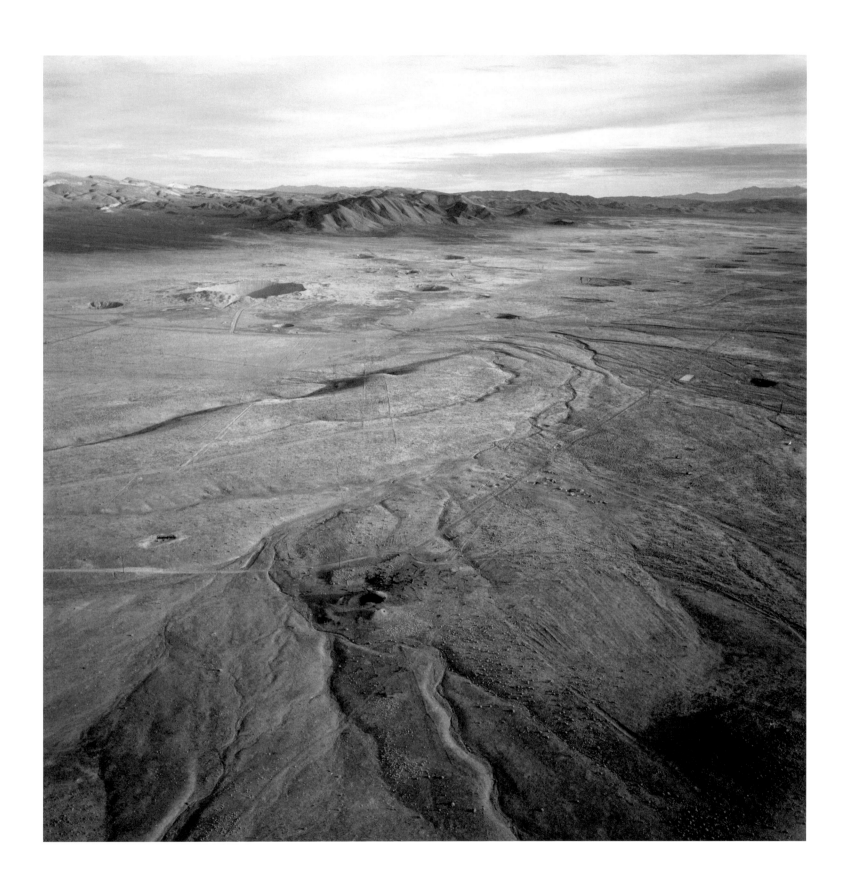

PLATE 30

LOOKING NORTHWEST TOWARD A SMALL HUMAN-MADE CLEARING, NEVADA TEST SITE, 1997

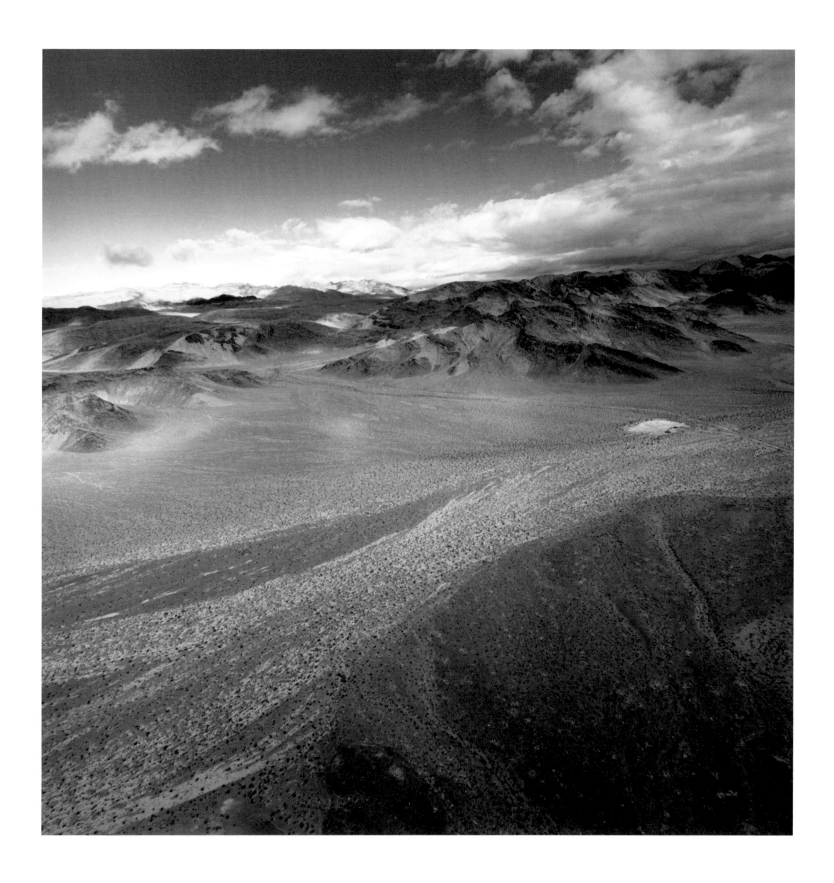

YUCCA FLAT DETAIL, LOOKING SOUTHWEST IN AREA 10, NEVADA TEST SITE, 1997

Ess Crater, on the near right with Twin Points, conducted March 23, 1955. Ess was one of the first underground nuclear tests but was clearly not contained. Directly above Ess is Corduroy, with a 150-kiloton yield, December 3, 1965.

37°10'12.73" N 116°2'25.09" W

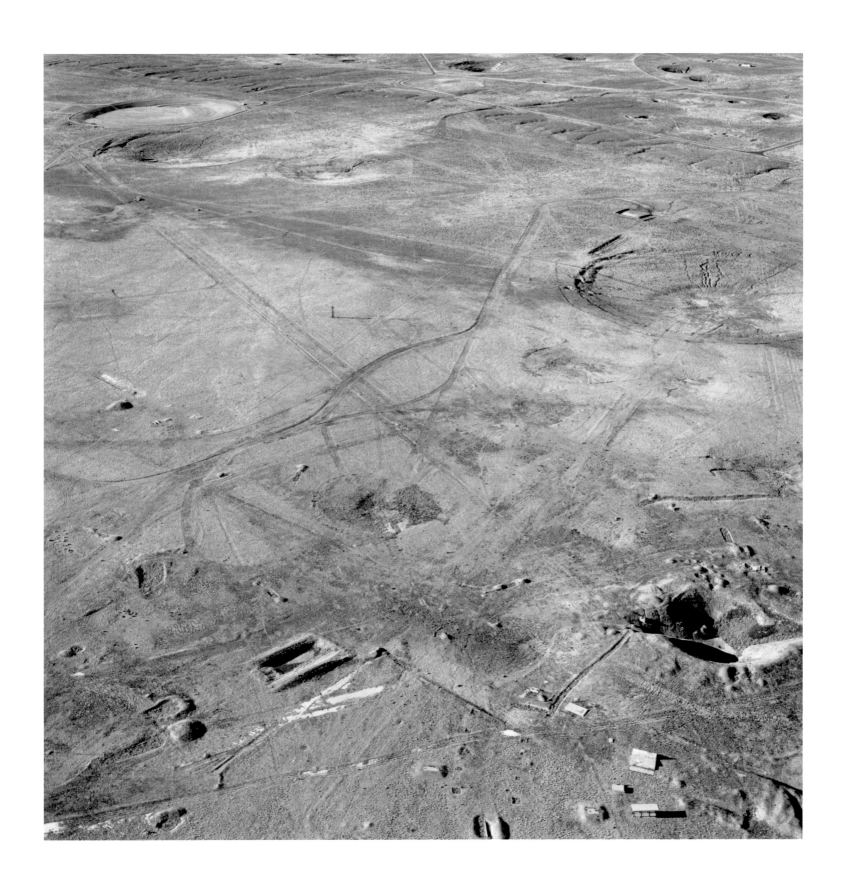

YUCCA FLAT, LOOKING NORTHEAST TOWARD GROOM LAKE AS MERCURY HIGHWAY CURVES
TOWARD GROOM PASS WITH AREA 51 IN THE DISTANCE, NEVADA TEST SITE, 1997

37°10'0.20" N 116°2'46.46" W

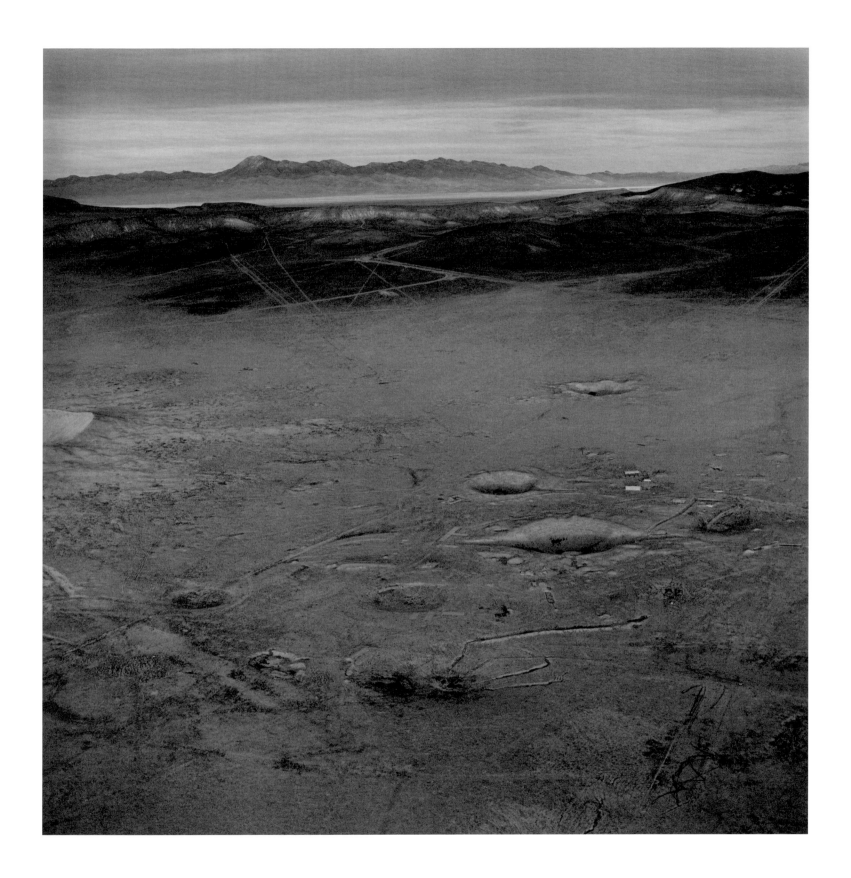

PLATE 33

SEDAN CRATER, NORTHERN PART OF YUCCA FLAT, LOOKING SOUTHEAST,
BANDED MOUNTAINS IN THE DISTANCE, NEVADA TEST SITE, 1996

Part of Operation Plowshare, the Sedan test was intended to develop peaceful uses for nuclear weapons.
On July 6, 1962, the Sedan device exploded with a yield of 104 kilotons, similar to the warhead of the Minuteman I missile.
Sedan was buried only 635 feet below the surface. The blast produced a crater approximately 1,200 feet wide and 330 feet deep,
displacing 12 million tons of earth and releasing high levels of radiation into the atmosphere.

37°10'51.53" N 116°2'48.14" W

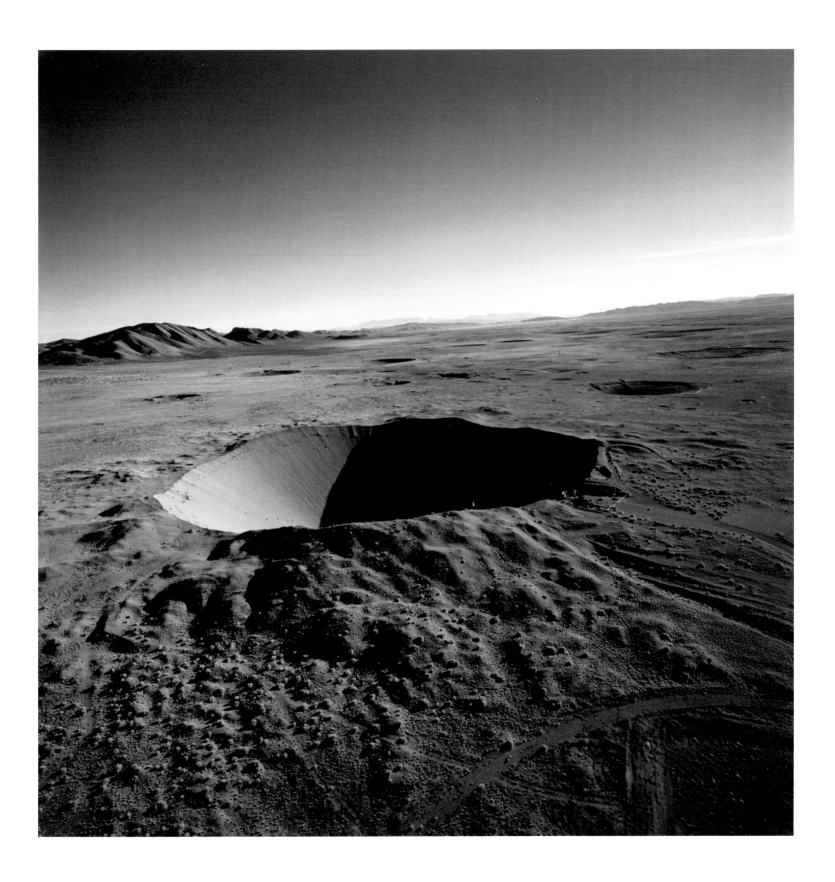

PLATE 34

LOOKING NORTHWEST FROM THE NORTHWEST END OF YUCCA FLAT, AREA 2, NEVADA TEST SITE, 1997

Subsidence craters created by the underground nuclear tests Frisco, September 23, 1982; Vide, April 30, 1981; Cottage, March 23, 1985; Norbo, March 8, 1980; and Seco, February 25, 1981.

37°10'0.26" N 116° 2'56.73" W

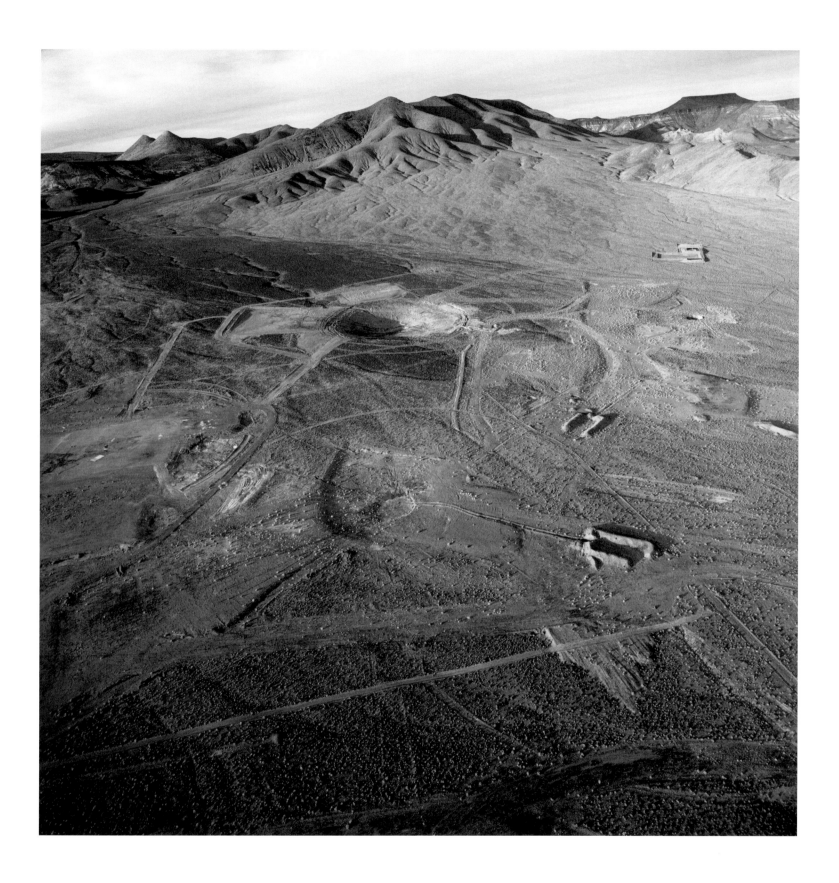

PLATE 35

SUBSIDENCE CRATERS CONVERTED FOR RADIOACTIVE WASTE STORAGE AND BURIAL,
AREA 7, NEVADA TEST SITE, 1997

Craters from the 38-kiloton test Turf, conducted April 24, 1964, and the 20-kiloton test Santee, conducted October 27, 1962, were later converted into a site for radioactive waste burial. On the right is the still-distinct crater of the February 8, 1963, weapons-related nuclear test Casselman, part of Operation Storax.

37°9'1.75" N 116°3'41.62" W

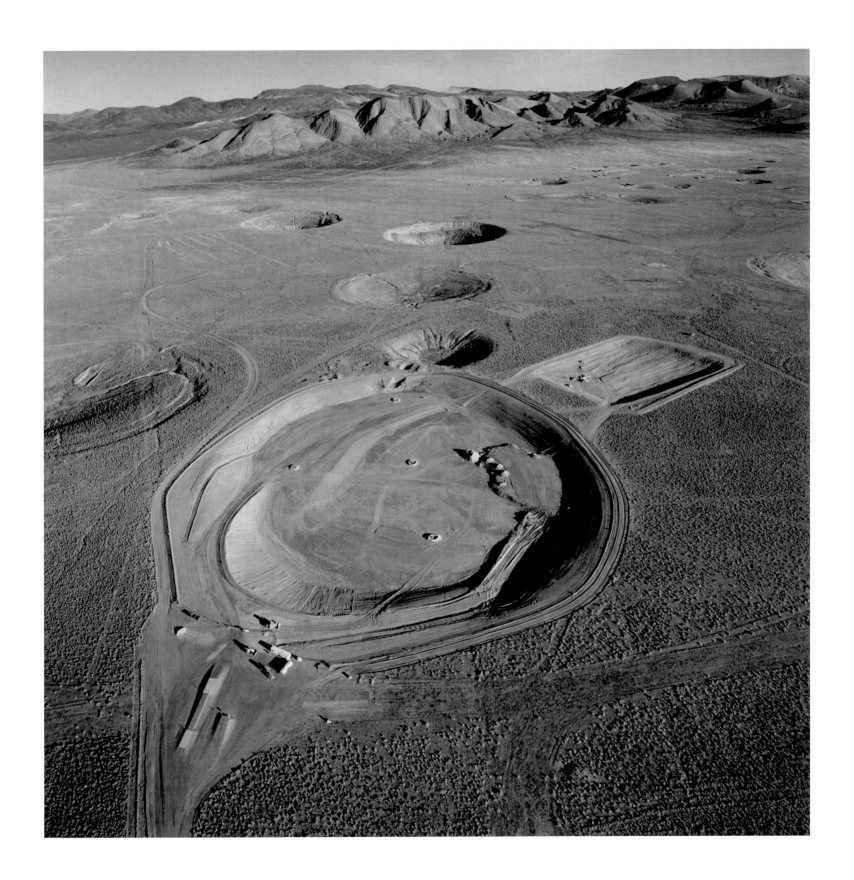

PLATE 36

LARGE CIRCULAR ARRAY OF UNDERGROUND TEST SUBSIDENCE CRATERS ON THE NORTHWEST
SIDE OF YUCCA FLAT, AREA 2, NEVADA TEST SITE, 1997

37°9'2.64" N 116°4'4.66" W

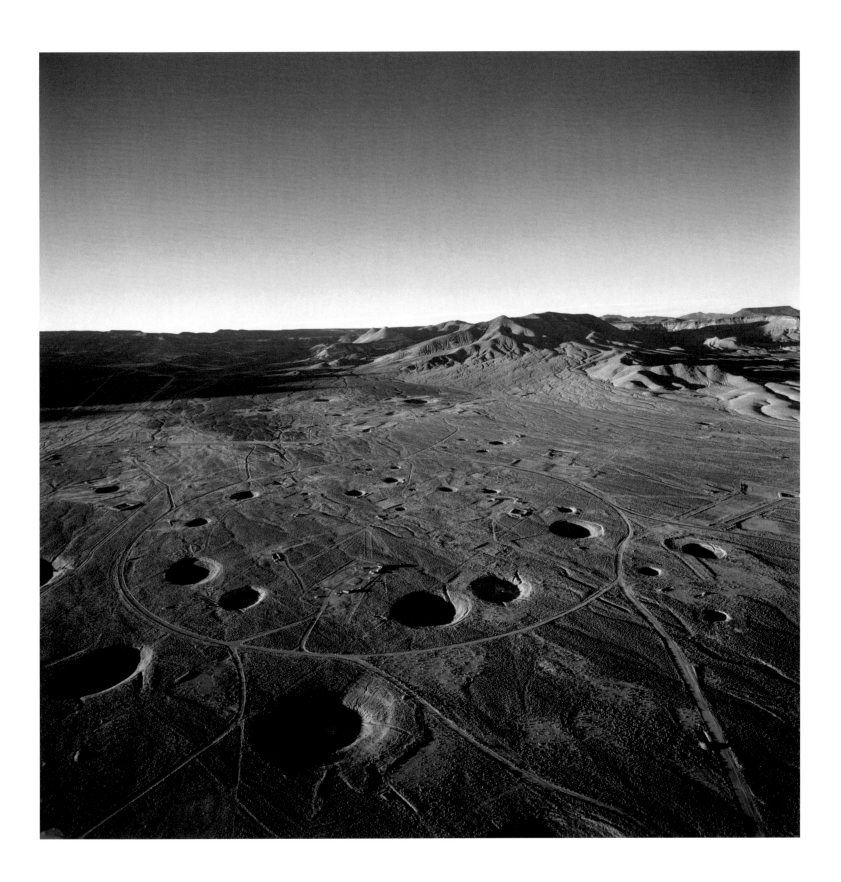

PLATE 37

THE EASTERN SIDE OF YUCCA FLAT, LOOKING EAST, AREA 9, NEVADA TEST SITE, 1997

The site of a weapons-related underground shaft test, Horehound, which had a yield of less than 20 kilotons
and was part of Operation Mandrel, August 27, 1969.

36°59'29.08" N 116°0'5.81" W

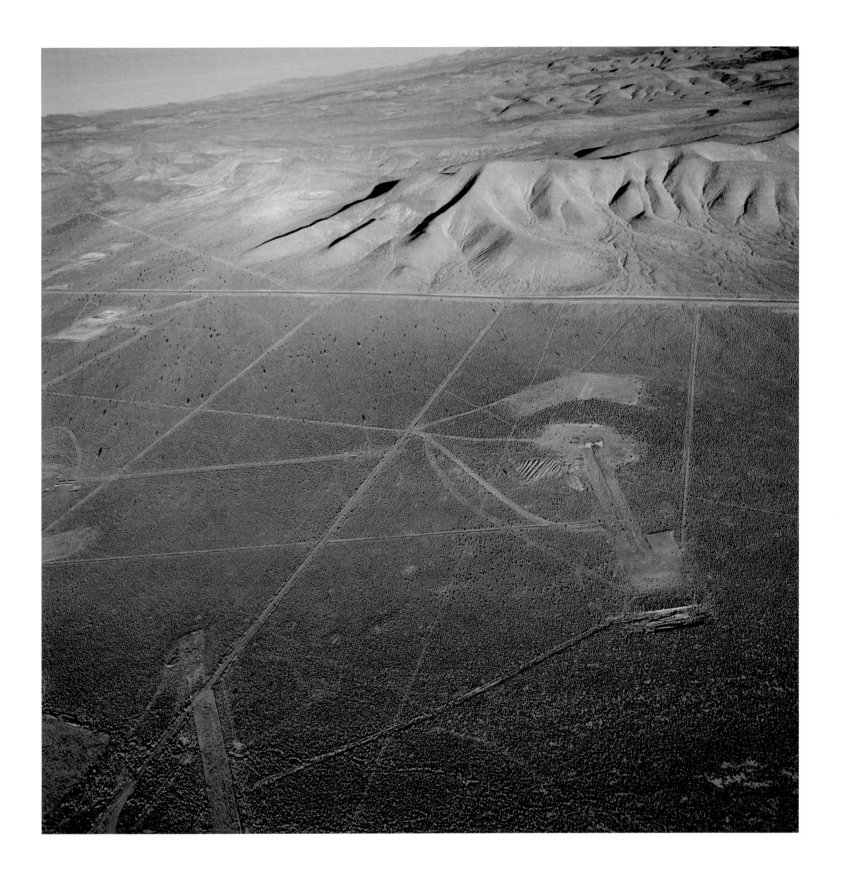

PLATE 38

**THREE SUBSIDENCE CRATERS WITHIN A SECURITY FENCE, LOOKING WEST, AREA 10,
NEVADA TEST SITE, 1996**

On the left is Normanna, conducted July 12, 1984; at the center is Jarlsberg, conducted August 27, 1983; and on the right is Brie,
conducted June 18, 1987. Each had an approximately 20-kiloton yield.

37°11'38.08" N 116°1'47.92" W

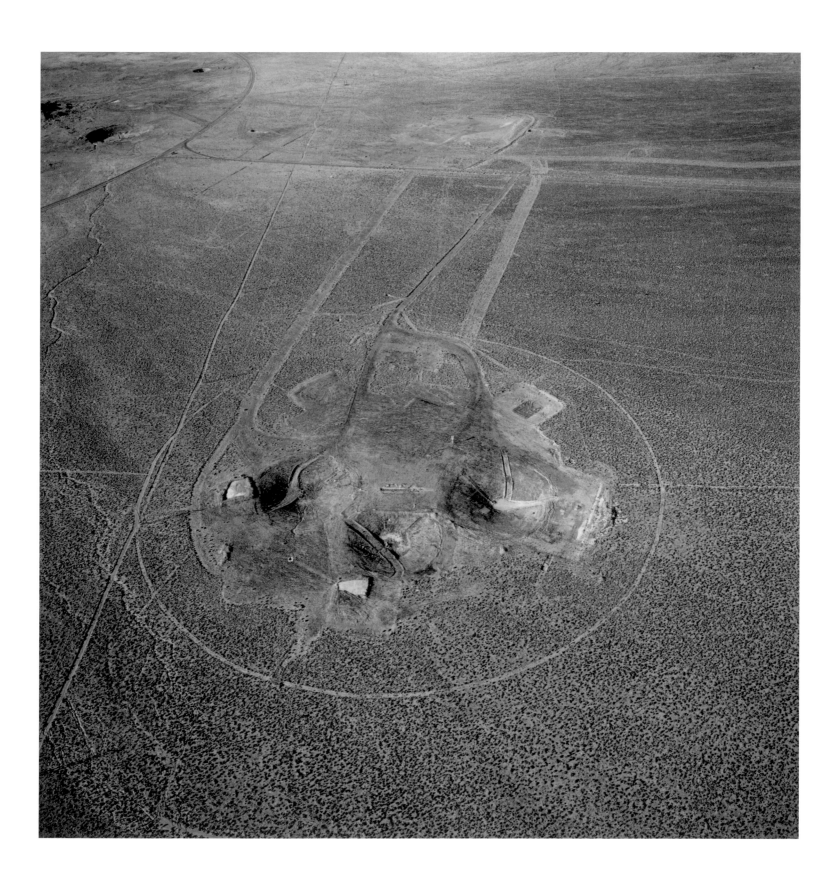

PLATE 39

AREA 5 RADIOACTIVE WASTE BURIAL SITE, NORTH OF FRENCHMAN FLAT, NEVADA TEST SITE, 1996

36°50'20.30" N 115°58'15.44" W

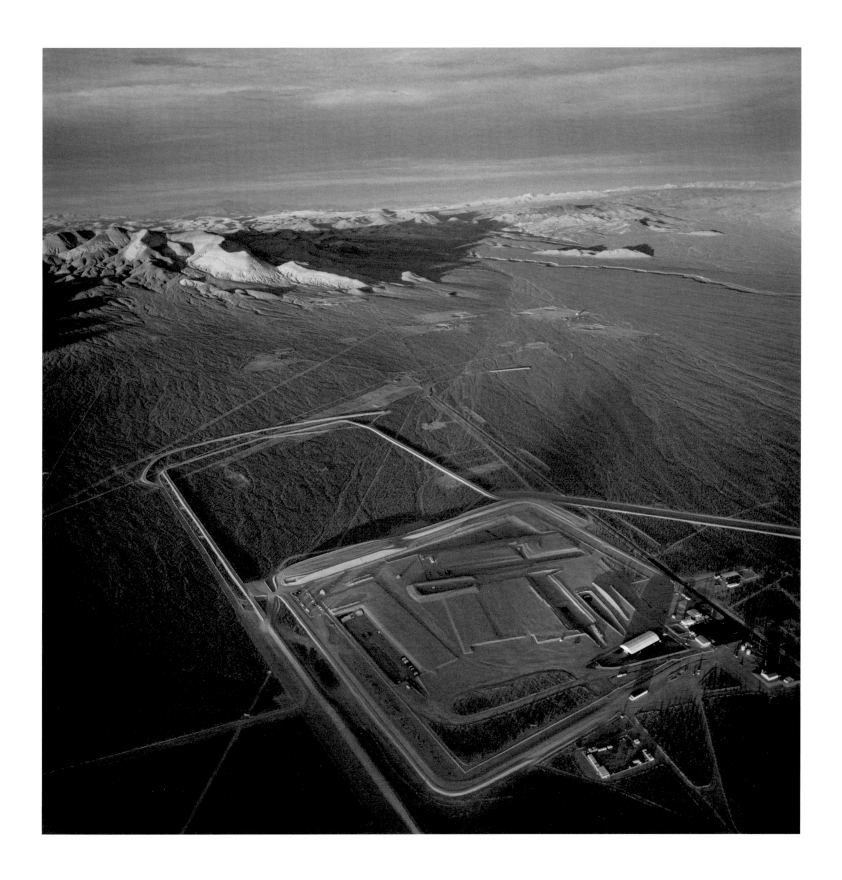

PLATE 40

SUBSIDENCE CREATED BY THE 150-KILOTON UNDERGROUND NUCLEAR TEST COTTAGE,
MARCH 23, 1985, YUCCA FLAT, AREA 2, NEVADA TEST SITE, 1997

37°10'46.09" N 116°5'16.40" W

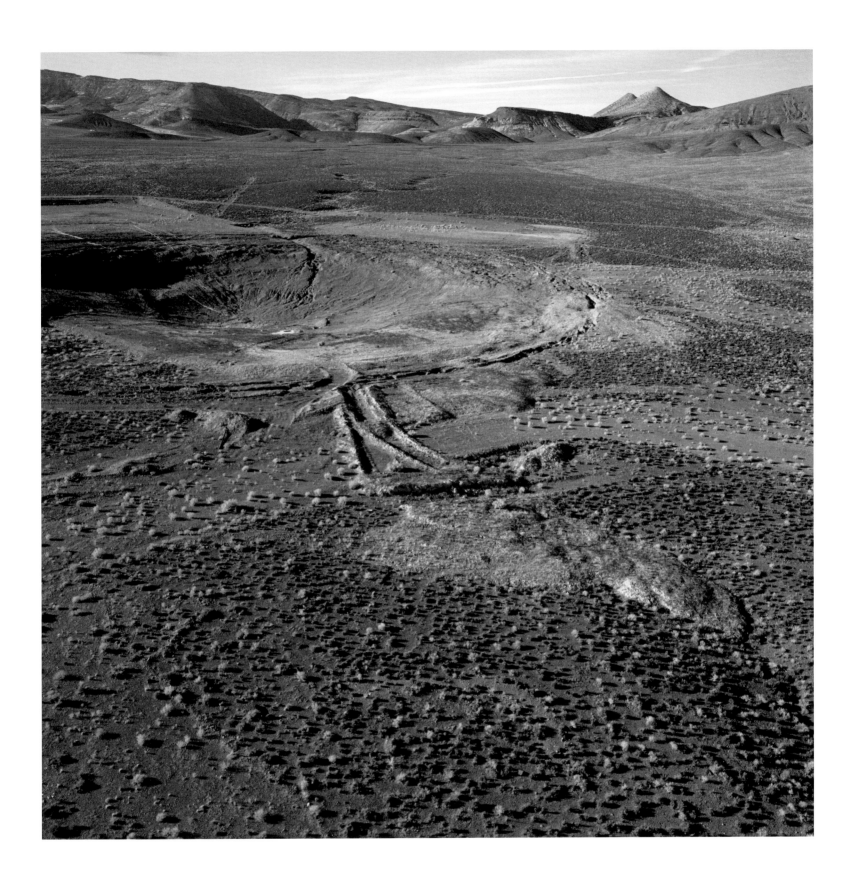

PLATE 41

FRENCHMAN FLAT, LOOKING SOUTHEAST, NEVADA TEST SITE, 1996

Radioactive silt and soils have been removed from the distant dark rectangles for burial. A common ground zero
for many aboveground tests is suggested by the radiating sight lines and a darkened center point.

36°48'42.26" N 115°55'49.61" W

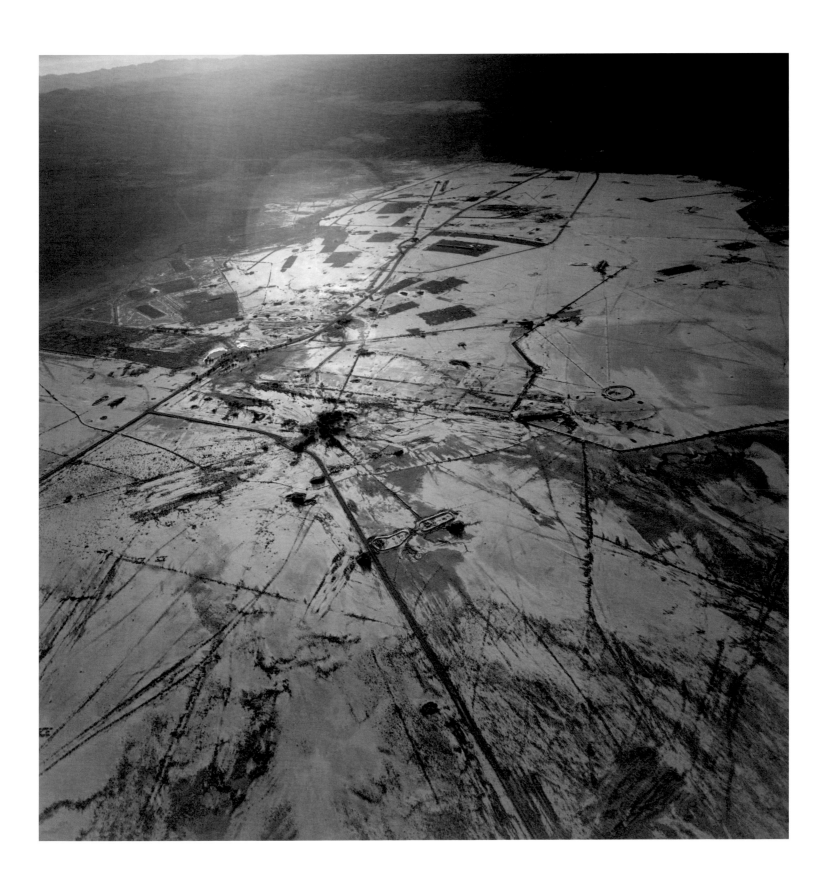

PLATE 42

NUCLEAR TEST CRATERS ON YUCCA FLAT, AREA 10, NEVADA TEST SITE, 1996

Sedan is the large crater surrounded by debris. Ess, with its opposite points, is center left. Uncle is to its immediate right, and farther right is Buster Jangle. Northwest of Ess is Kankakee, conducted June 15, 1966. In the foreground is Cornice-Green, with its twin, Cornice-Yellow, on the near right. These two tests were conducted simultaneously on May 15, 1970.

37°9'34.68" N 116°2'13.67" W

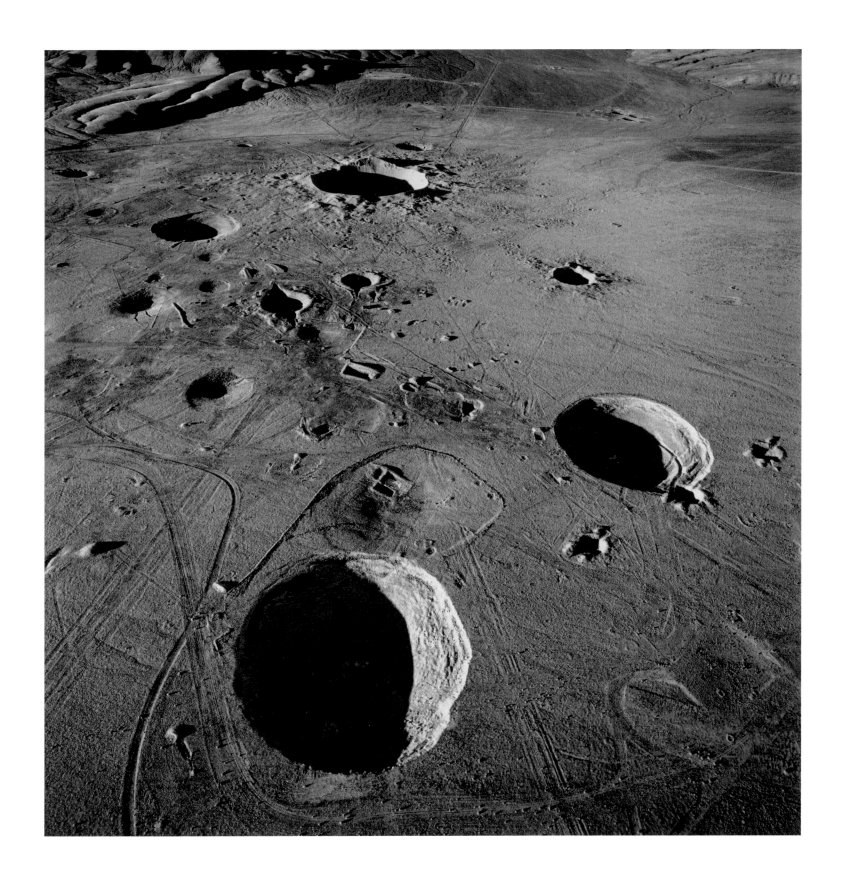

PLATE 43

ROAD TO THE TWEEZER COMPLEX, LOOKING NORTHEAST TOWARD PLUTONIUM VALLEY,
NEVADA TEST SITE, 1996

36°56'11.70" N 115°59'4.81" W

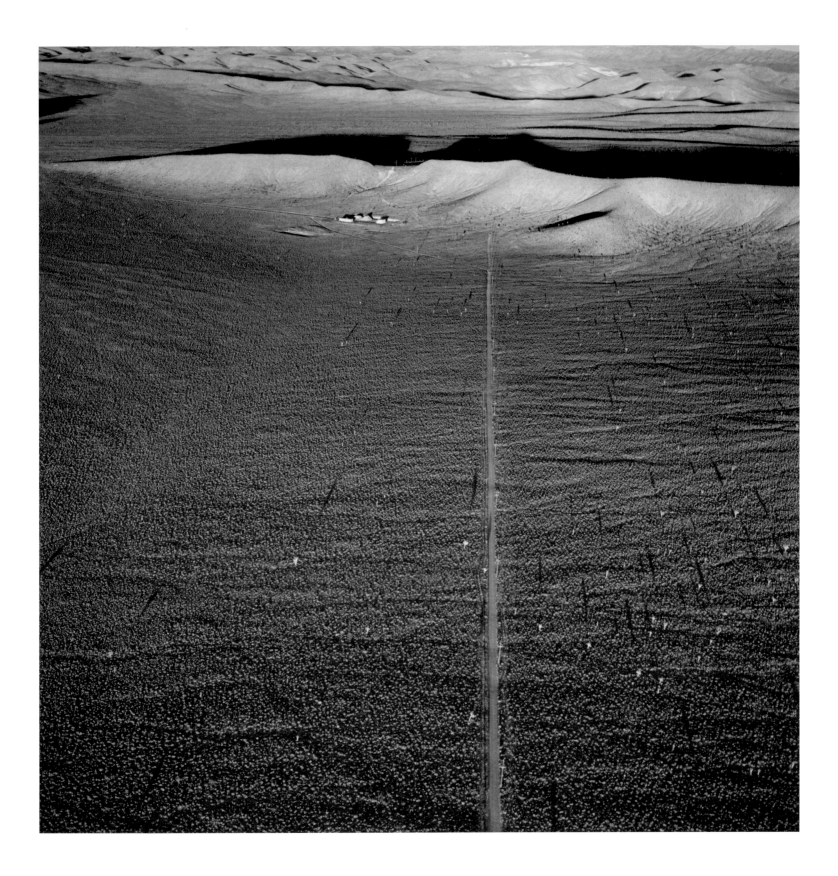

PLATE 44

THE NORTHERN EDGE OF FRENCHMAN FLAT, SHOWING THE AREA 5
RADIOACTIVE WASTE BURIAL SITE IN THE DISTANCE, NEVADA TEST SITE, 1997

Diluted Waters, a 4-kiloton test, June 16, 1965; and Wishbone, a 5-kiloton test, February 18, 1965.

The Department of Energy reports that Diluted Waters produced an "accidental release of radioactivity detected off-site."

36°48'40.37" N 115°57'09.27" W

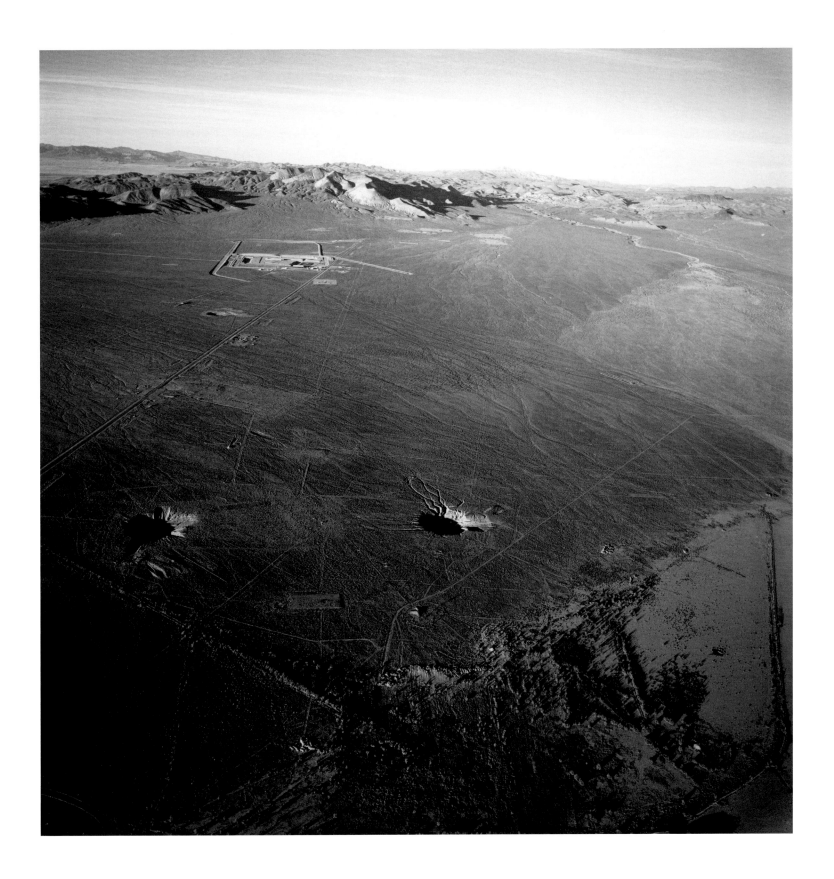

PLATE 45

SUBSIDENCE CRATER FROM THE BILBY TEST, SEPTEMBER 13, 1963, WITH A 249-KILOTON YIELD,
AREA 3, NEVADA TEST SITE, 1996

The Department of Energy lists Bilby as the first underground test reportedly felt in Las Vegas.

37°3'41.04" N 116°1'26.02" W

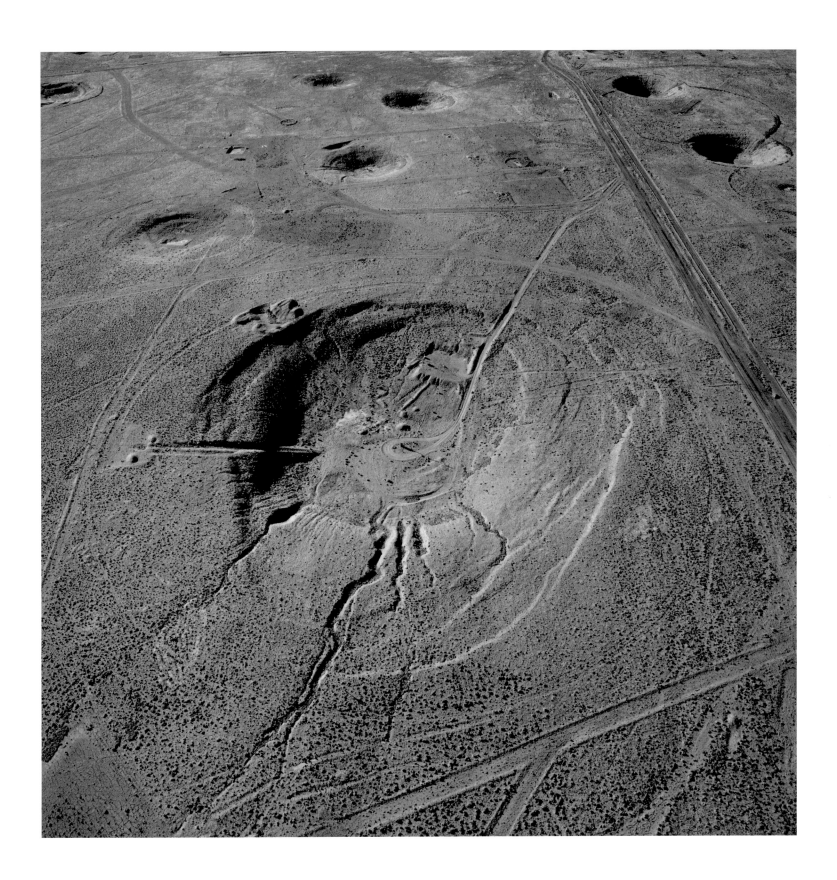

MERCURY HIGHWAY AND THE CENTER OF YUCCA FLAT, LOOKING SOUTHEAST, AREAS 7 AND 9,
NEVADA TEST SITE, 1996

37°8'28.36" N 116°2'19.71" W

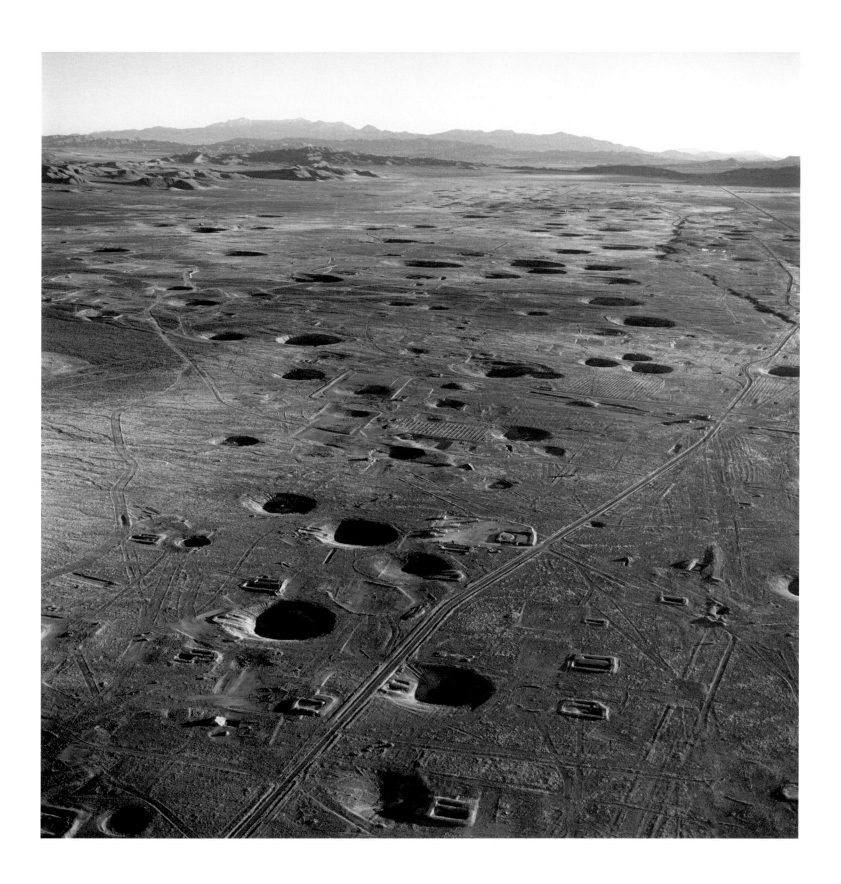

PLATE 47

DETAIL OF FRENCHMAN FLAT AFTER SUNSET, LOOKING NORTHEAST, NEVADA TEST SITE, 1997

36°47'14.28" N 115°57'31.26" W

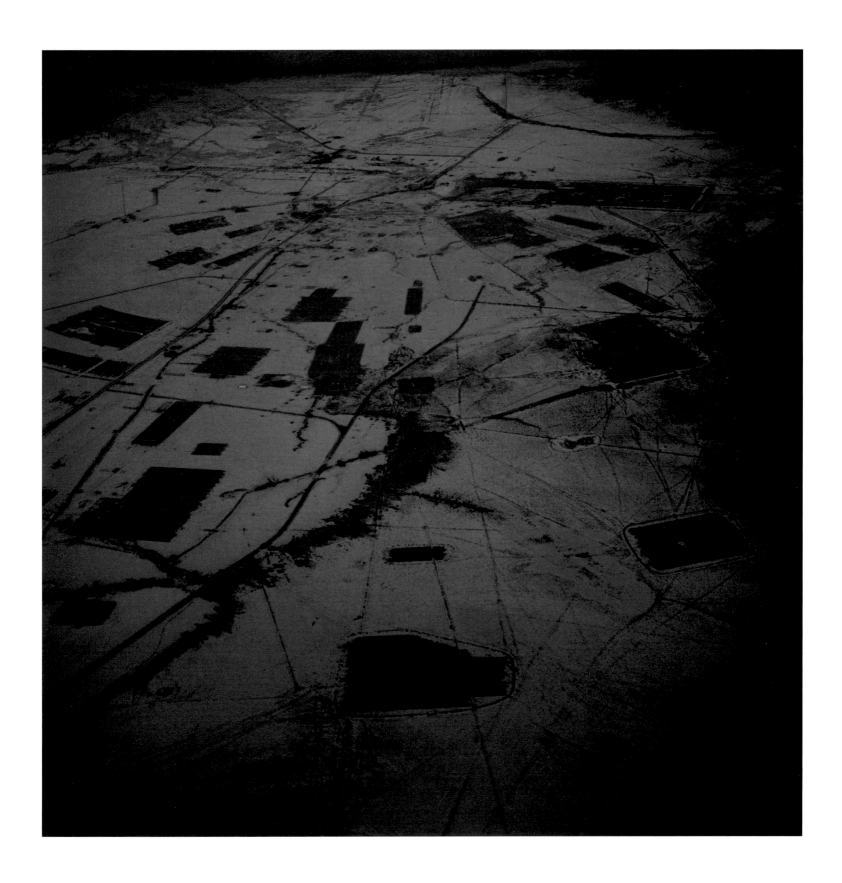

PLATE 48

SUBSIDENCE CRATERS, NORTHERN END OF YUCCA FLAT, WITH THE YUCCA FAULT STRONGLY
SHADOWED AT THE LEFT, LOOKING NORTH, NEVADA TEST SITE, 1996

Beginning with the nearest and largest crater: Rudder, December 28, 1976, 150 kilotons; Esrom, February 4, 1976, 200 kilotons;
Stones, May 22, 1963, 200 kilotons.

37°5'48.31" N 116°2'22.13" W

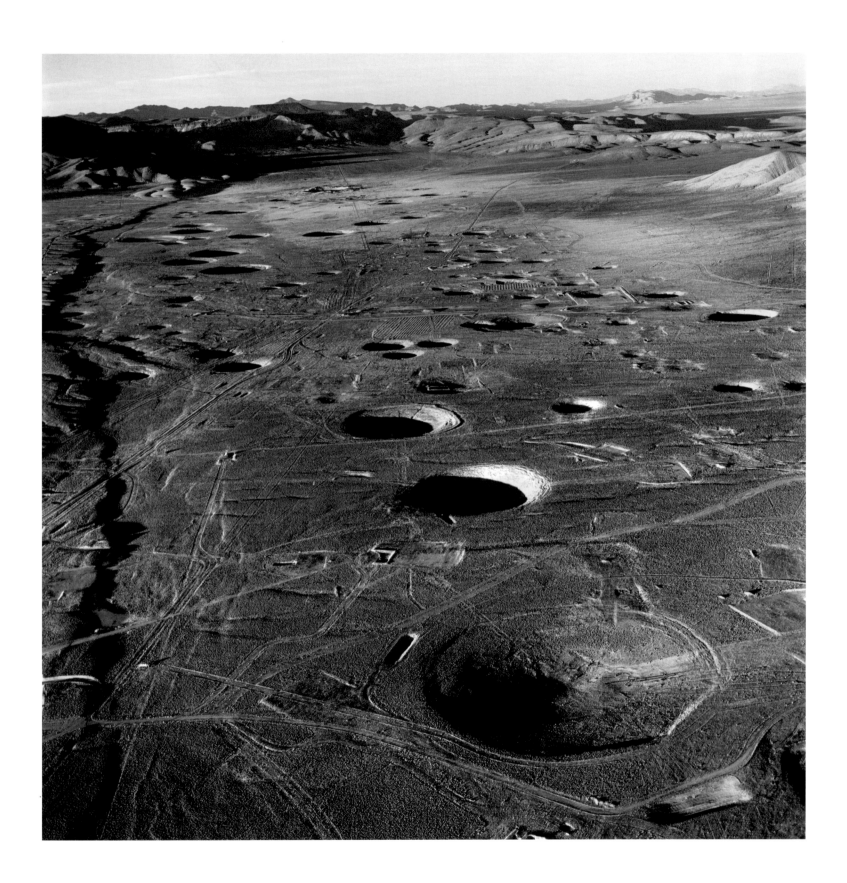

**FRENCHMAN FLAT, GROUND ZERO WITH LINE OF SIGHT MARKINGS AND AREAS
CLEARED OF RADIOACTIVE SOILS, LOOKING SOUTH, NEVADA TEST SITE, 1996**

Frenchman Flat is the reported site of at least fourteen of the earliest aboveground atmospheric tests. Problems with excessive dust and loss of visibility are said to have prompted moving subsequent atmospheric tests from Frenchman Flat to Yucca Flat.

36°48'39.99" N 115°55'50.89" W

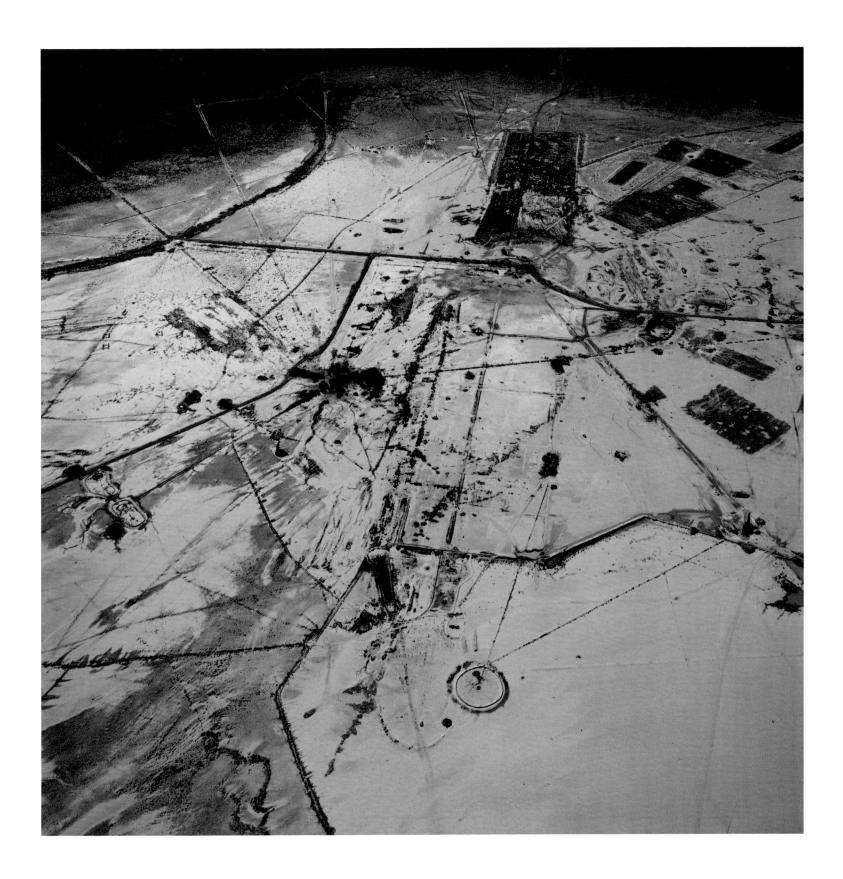

PLATE 50

SUBSIDENCE CRATERS AND THE YUCCA FAULT, LOOKING NORTH ON YUCCA FLAT,
NEVADA TEST SITE, 1996

Department of Energy reports that between 1945 and 1992, the United States conducted 100 aboveground or atmospheric
tests and 904 underground nuclear tests at the Nevada Test Site. We must also add another 24 underground tests that were
conducted jointly by the US-UK. The majority of these 928 tests were performed here on Yucca Flat.

In this image, the path of the Mercury Highway, now rerouted, must have been momentarily blocked by the Caprock test of
Operation Fusileer, a 150-kiloton weapons-related test on May 31, 1984.

37°5'56.71" N 116°2'49.60" W

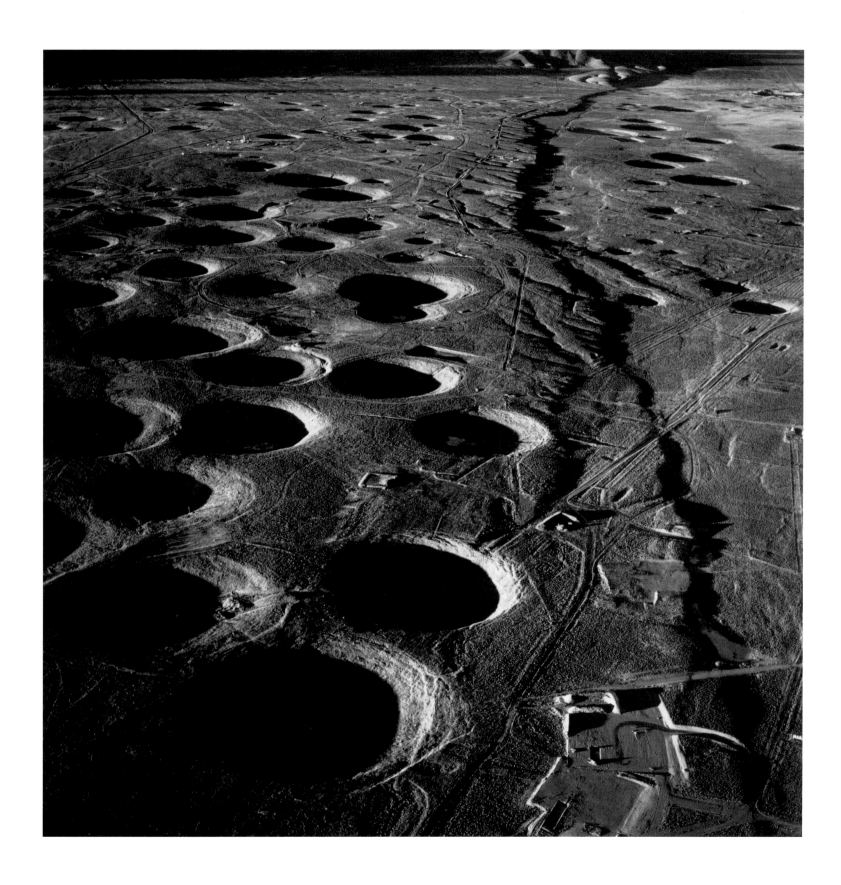

PLATE 51

FRENCHMAN FLAT, LINE OF SIGHT MARKINGS AND AREAS CLEARED OF RADIOACTIVE SOILS,
LOOKING SOUTHEAST, NEVADA TEST SITE, 1996

36°47'50.47" N 115°56'15.82" W

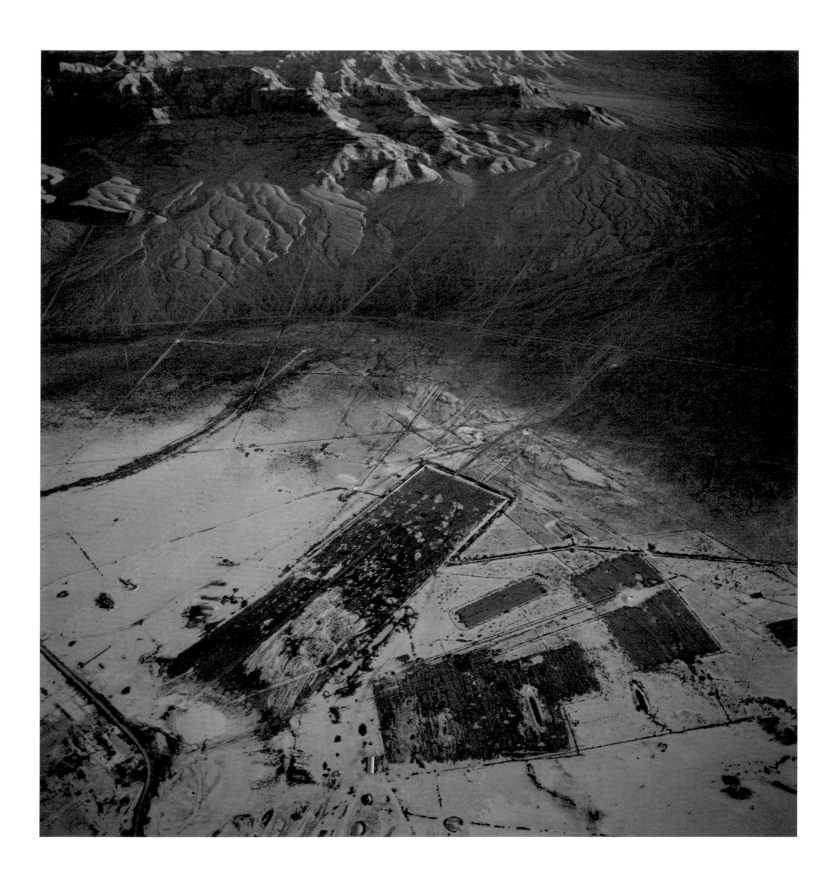

PLATE 52

YUCCA FLAT, LOOKING WEST TOWARD THE YUCCA FAULT, AREA 10, NEVADA TEST SITE, 1996

The foremost craters are Cornice-Yellow and Cornice-Green, left and center, each with a yield of 45 kilotons.
The two tests were conducted simultaneously on May 15, 1970.

37°10'0.27" N 116°1'58.36" W

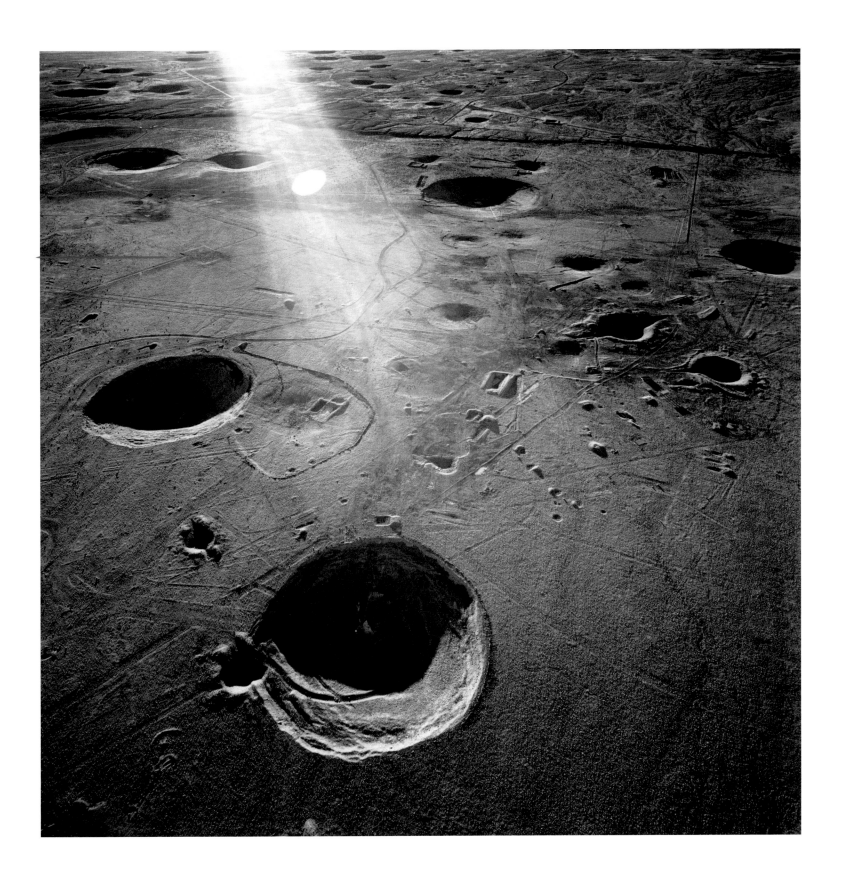

SEDAN CRATER WITH OUR HELICOPTER SHADOW, LOOKING EAST, AREA 10, NEVADA TEST SITE, 1996

37°10'33.67" N 116°3'7.16" W

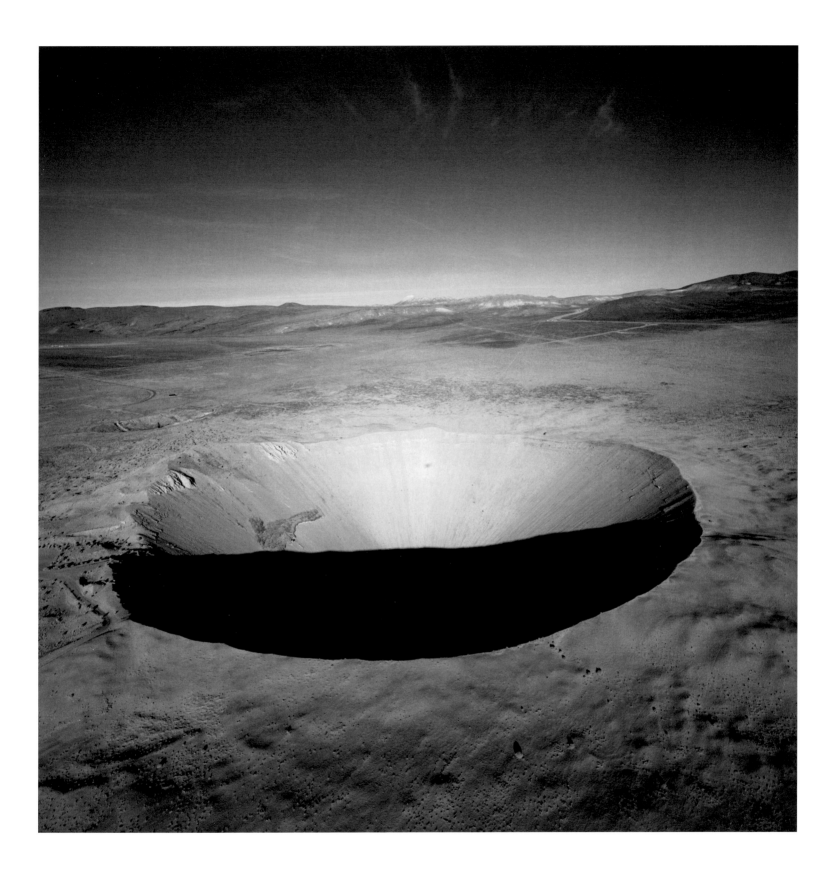

PLATE 54

SUBSIDENCE CRATERS AND DIAGNOSTIC ARRAY, LOOKING NORTHEAST, AREA 7, NEVADA TEST SITE, 1996

The large subsidence crater is Atrisco, part of Operation Praetorian, August 5, 1982, with a yield of 138 kilotons.
Above the Atrisco crater are the fiber-optic cables from the Floydada test. Part of Operation Sculpin, Floydada was a weapons-
related shaft test, August 15, 1991, with a yield of less than 20 kilotons. In the distance is the Bellow test crater, May 16, 1984.

37°4'56.30" N 116°0'31.88" W

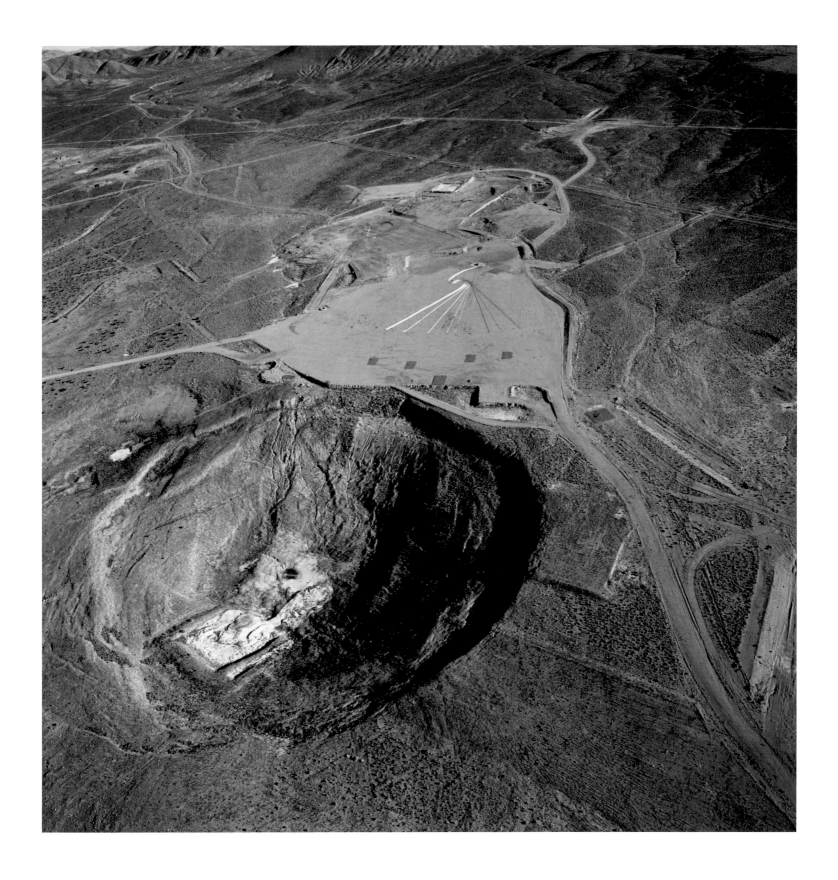

PLATE 55

SOIL FRACTURES DRAPED WITH FIBER-OPTIC CABLE ALONG THE RIM OF A COLLAPSED
SUBSIDENCE CRATER, YUCCA FLAT, AREA 2, NEVADA TEST SITE, 1997

Part of Operation Grenadier, Cottage was a weapons-related test conducted on March 23, 1985, with a yield of approximately 150 kilotons.

37°10'18.1" N 116°57'8.2" W

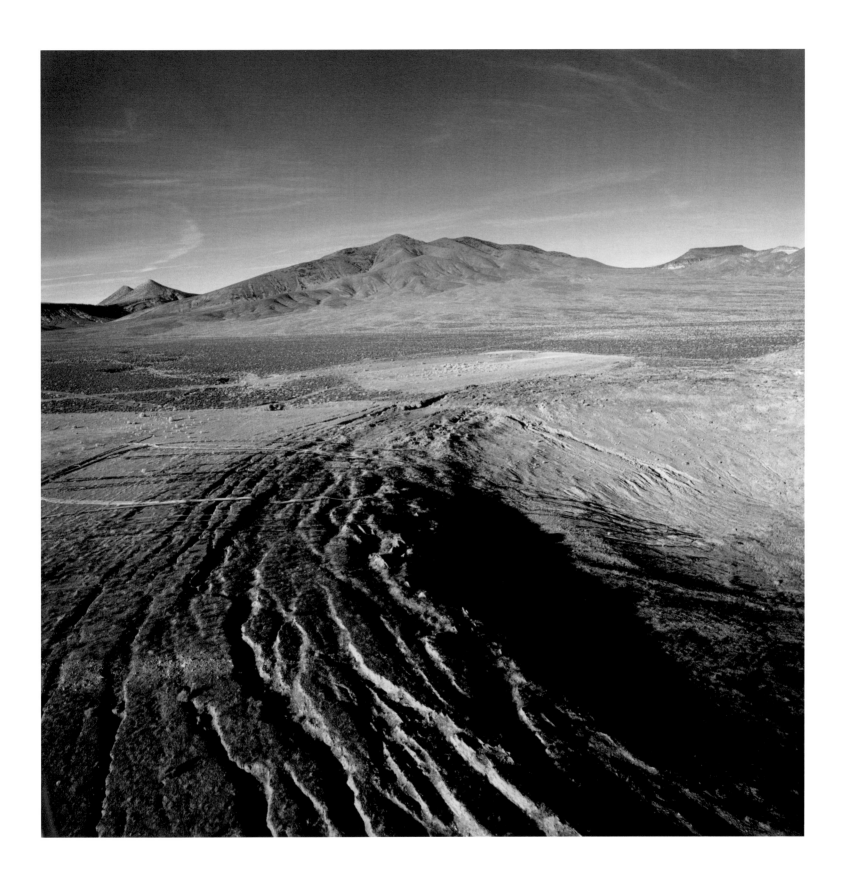

PLATE 56

YUCCA FLAT, LOOKING EAST TOWARD SLANTED BUTTES, EAST SIDE OF AREA 3, NEVADA TEST SITE, 1997

In the midfield near the road bend are two craters, named Fade, June 25, 1964, and Chenille, April 22, 1965, with yields of 6 and 1 kiloton, respectively.

37°6'37.77" N 116°2'17.28" W

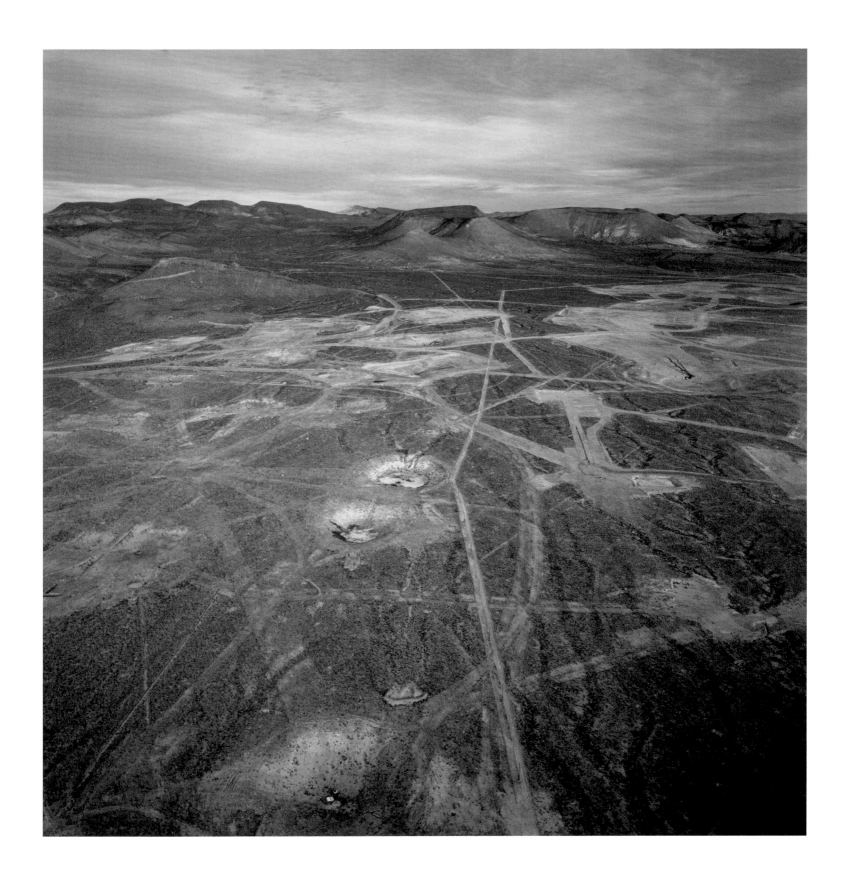

PLATE 57

YUCCA FLAT, LOOKING SOUTH, NEVADA TEST SITE, 1997

The nearest crater is designated as the shared site of two tests, Hognose, March 15, 1962, and Harkee, May 17, 1963.
Both tests were of unusually low yield and under 1 kiloton. The more distant subsidence crater was created by the 20-kiloton
underground shaft, weapons-related test, Daman I, June 21, 1962. The year 1962 is exceptional in that the Department of Energy
records show that ninety-eight nuclear tests were conducted in that one year, 1962, with sixty-two of those tests conducted in Nevada.

37° 2'47.95" N 116° 1'52.48" W

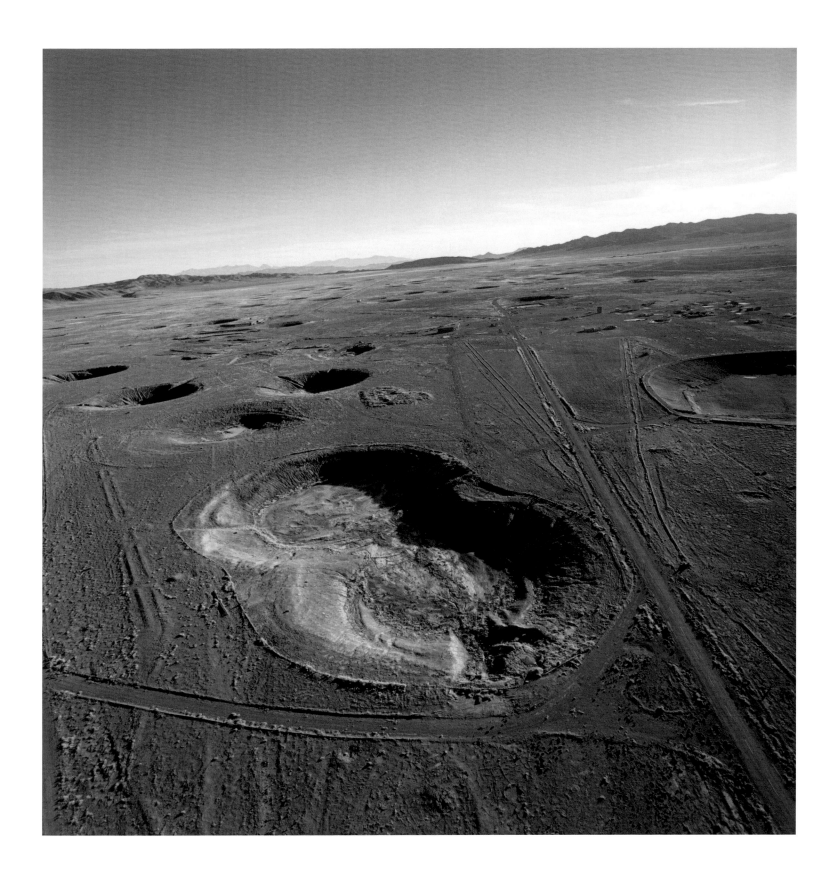

OVERVIEW OF FRENCHMAN FLAT, LOOKING WEST, NEVADA TEST SITE, 1997

36°49'5.24" N 115°54'18.55" W

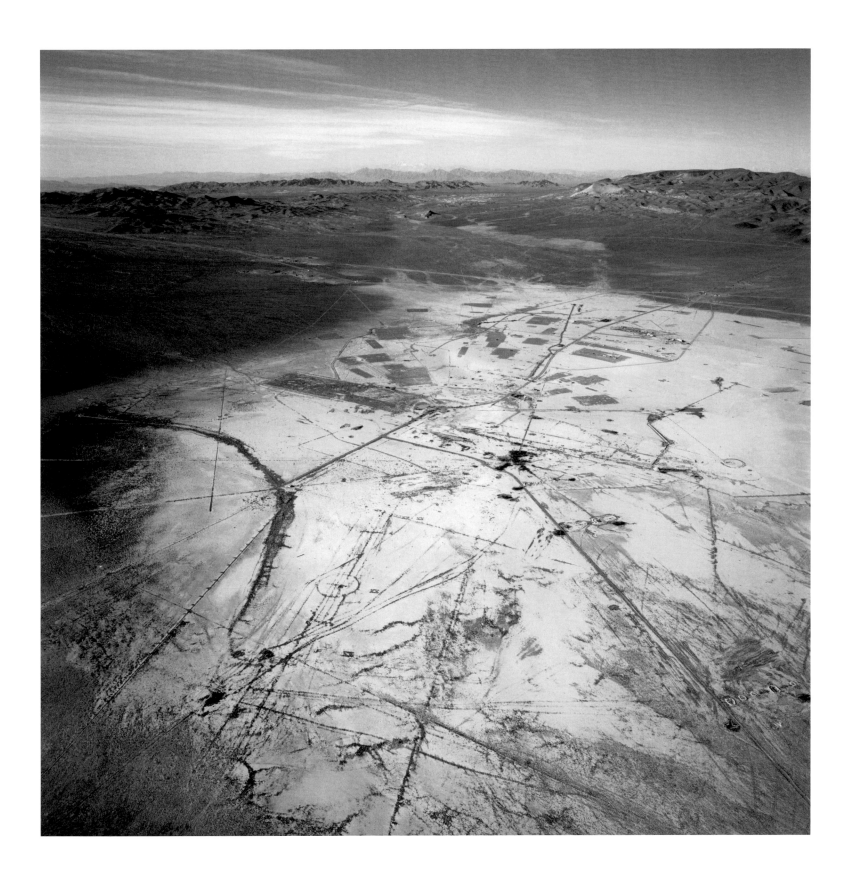

AREA 3 RADIOACTIVE WASTE MANAGEMENT SITE, LOOKING SOUTHEAST, NEVADA TEST SITE, 1996

37°3'0.86" N 116°1'54.50" W

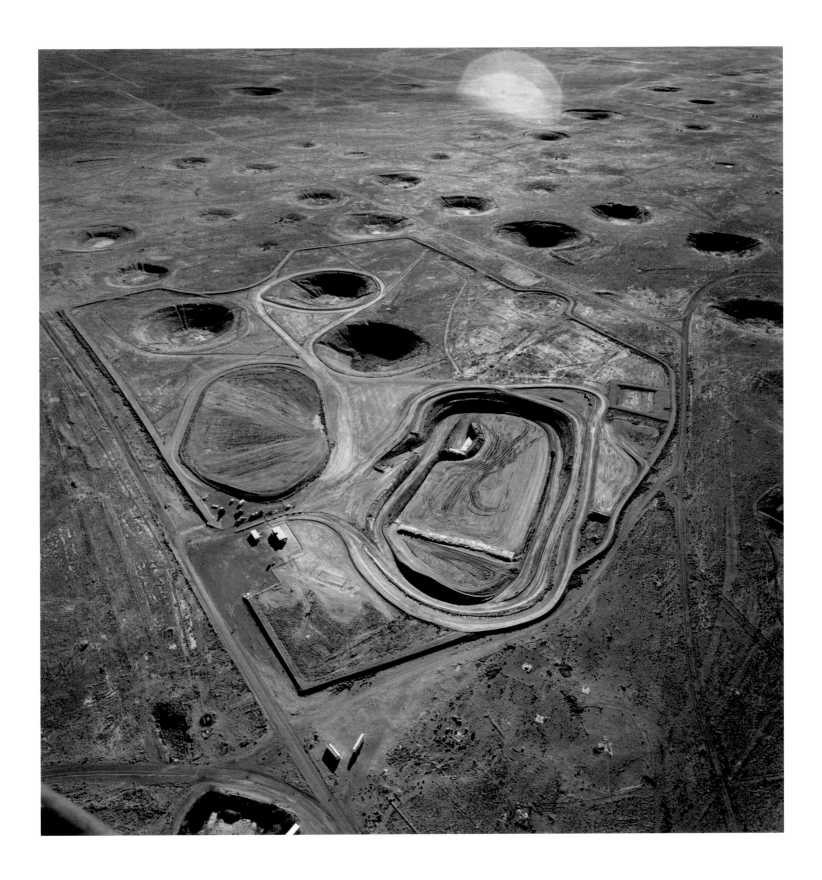

RIDGE SHADOWS AND HIDDEN SHADOWS AND THE ROAD TO THE TWEEZER COMPLEX,
AREA 11, NEVADA TEST SITE, 1997

36°54′48.63″ N 115°59′39.10″ W

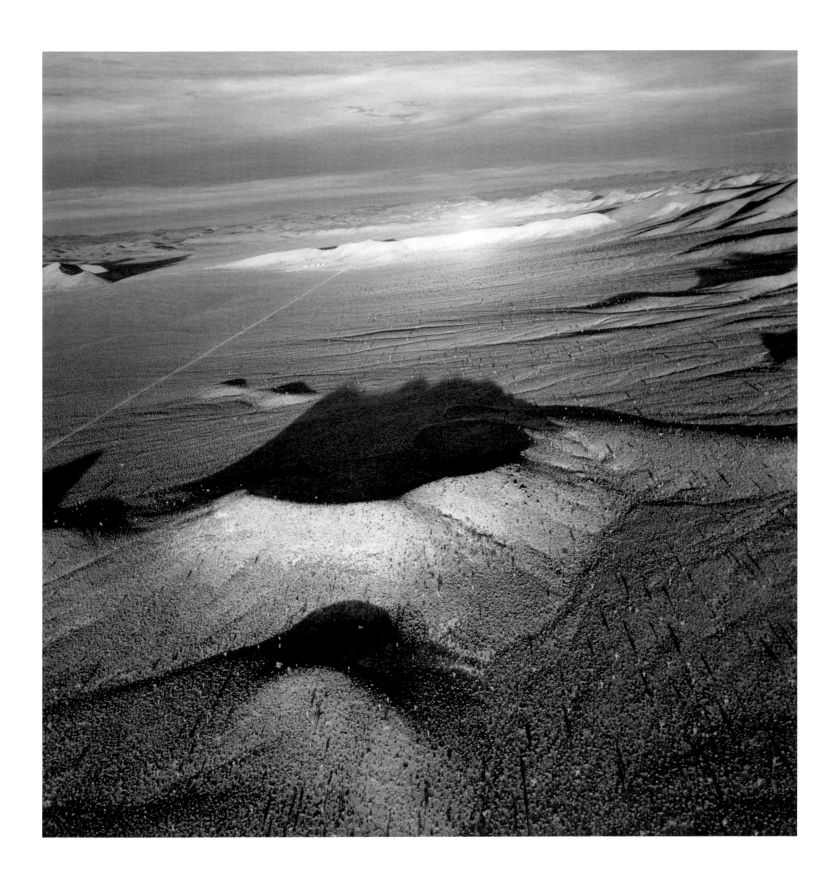

PLATE 61

FRENCHMAN FLAT, LOOKING WEST, NEVADA TEST SITE, 1996

36°47'25.11" N 115°56'35.99" W

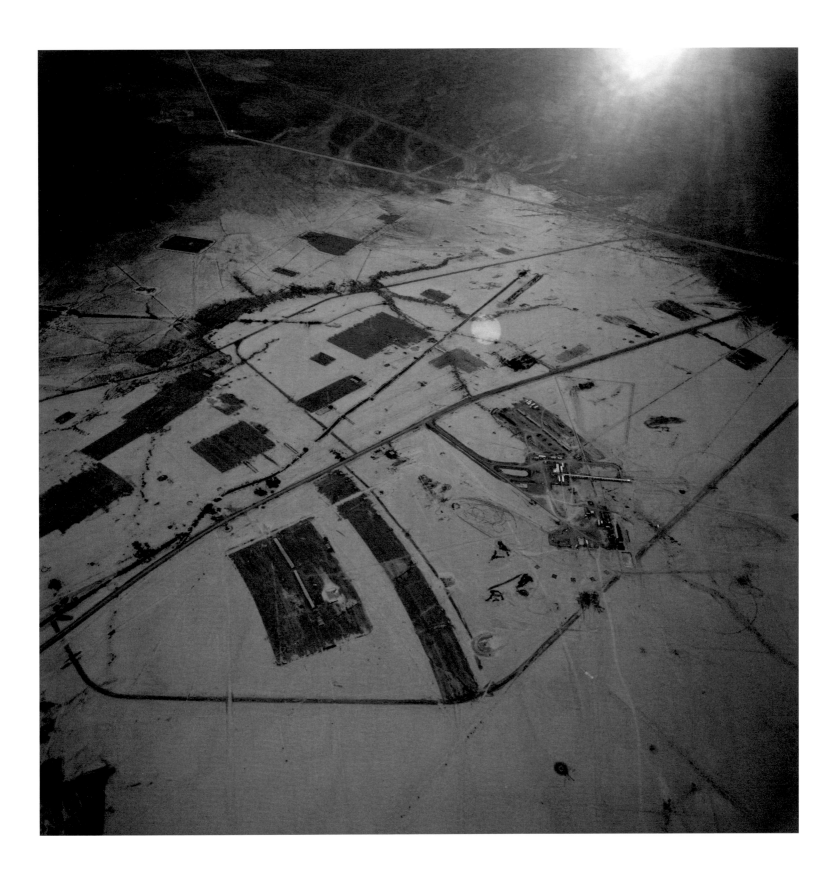

PLATE 62

SEDAN CRATER, NORTHERN END OF YUCCA FLAT, NEVADA TEST SITE, 1996

37°10'33.39" N 116°2'25.41" W

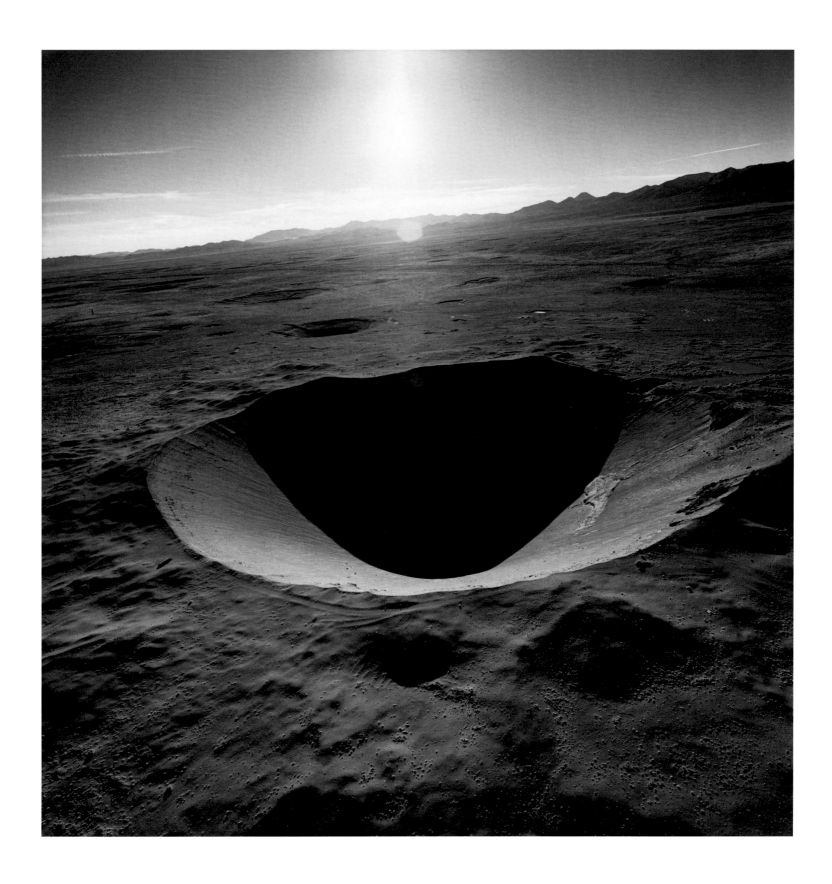

PLATE 63

STRUCTURAL DEBRIS, YUCCA LAKE, LOOKING WEST, AREA 6, NEVADA TEST SITE, 1997

This structural debris on Yucca Lake was said to be all that remains of a test associated with Operation Plowshares. Although this site use is unconfirmed, the aims of the Plowshares are well known and are described as exploring the uses of atomic explosions for peaceful goals such as canal digging or harbor creation.

36°58'20.60" N 115°59'50.64" W

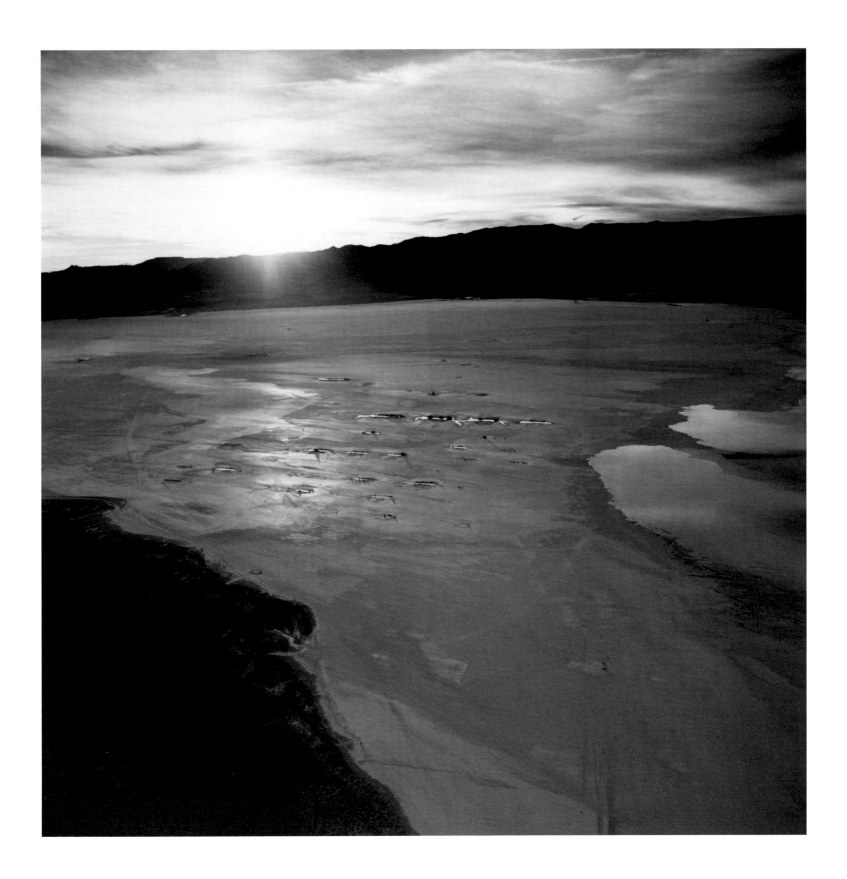

FRENCHMAN FLAT, LOOKING WEST, NEVADA TEST SITE, 1996

36°47'25.11" N 115°56'35.99" W

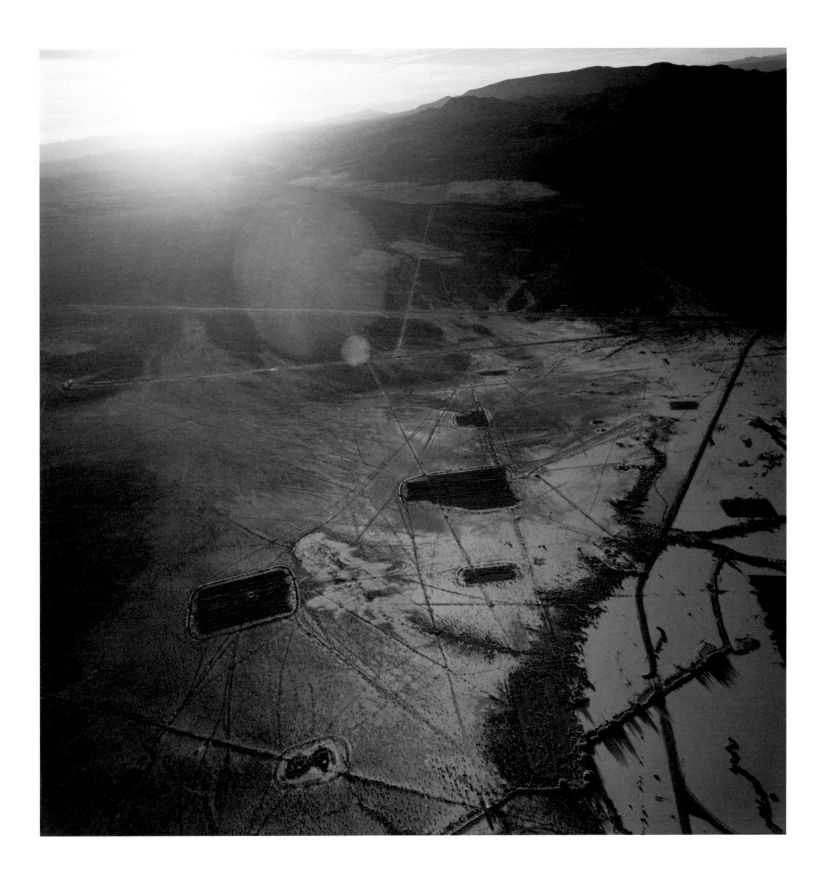

PLATE 65

GROUND ZERO AND LINES OF SIGHT FOR ATMOSPHERIC TESTS, FRENCHMAN FLAT,
NEVADA TEST SITE, 1996

36°47'53.08" N 115°56'13.29" W

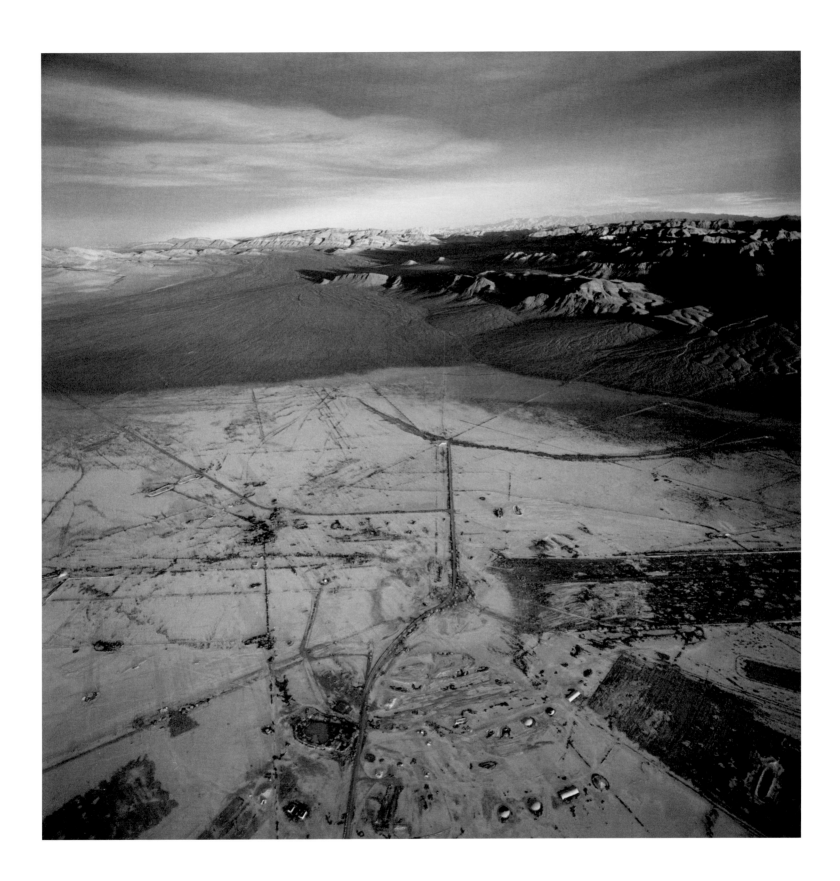

OVERVIEW OF FRENCHMAN FLAT, LOOKING SOUTH, NEVADA TEST SITE, 1997

36°49'35.42" N 115°56'26.45" W

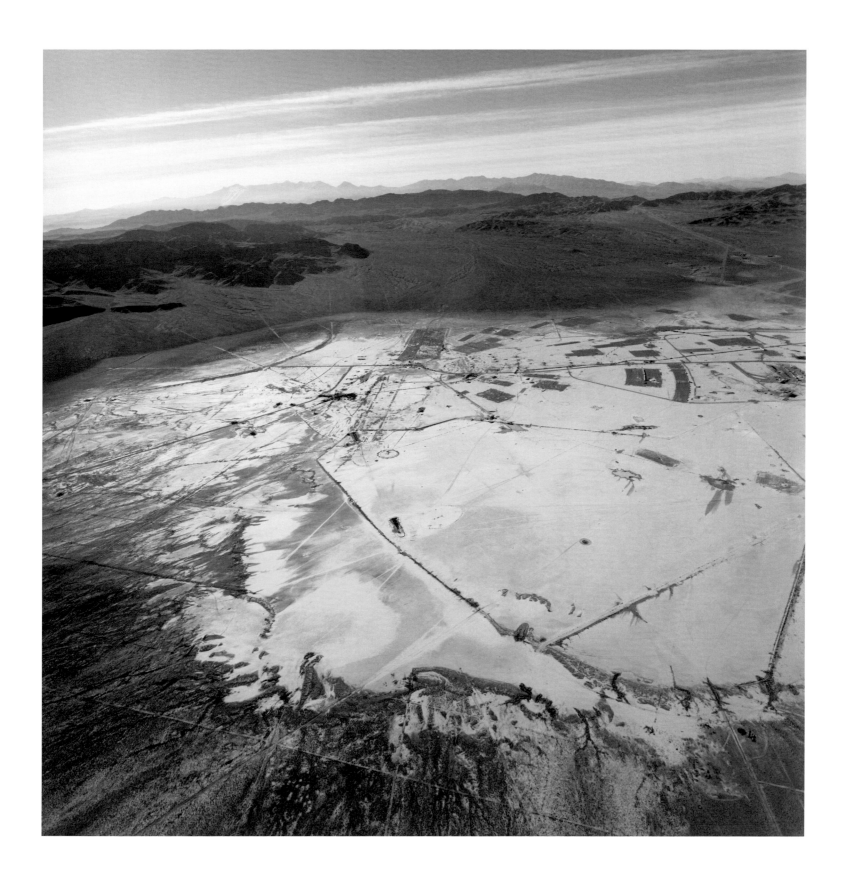

The Nevada Test Site

EMMET GOWIN

More nuclear bombs have been dropped on or have exploded in or above American soil than on that of any other country in the world. This is difficult to comprehend until we begin to consider the extent of nuclear testing in our own country over the last five decades of the twentieth century.

So many changes in our lives seem to come to us by providence, or by chance. I first became aware of nuclear testing in the United States by seeing the Hanford Nuclear Reservation in Washington State, and even that awareness came about fortuitously. In 1980, I accepted an invitation from the Seattle Arts Commission to photograph in Washington State. Then Mount Saint Helens erupted. Its eruption changed many lives, and it changed mine. That summer, what I'd meant to study gave way to larger questions I might never have chosen: questions about my perceptions of disaster or catastrophe, the geology of volcanism, and a deeper view of time.

In July 1980, with no possibility of getting anywhere near Mount Saint Helens by land, I photographed for the first time from a small plane. From this perspective, a landscape I had seen extensively in media coverage appeared to me wildly new and unused, its secrets untouched. I also found that from the air places and subjects usually forbidden or inaccessible were now fully visible, with a scope and wholeness that a close-up or ground view could never provide.

Over the next six years I returned to Mount Saint Helens at every chance. Meanwhile, a colleague had asked me to assist him in a project with the people of the Yakama Nation around the Hanford Site. His work involved the radioactive and chemical contamination of land and water. Looking back, I am startled now by the clear resolve I felt in saying no, no thank you; this would all make me too sad. Thus it was a surprise when only two years later, in 1986, as a huge and unexpected Pacific storm closed down my work at Mount Saint Helens, the thought of seeing the Hanford Nuclear Reservation returned. It was clear to me then that I was the one who had changed.

A flight out of the Yakima city airport was quickly arranged. I am still surprised that the air space over the Hanford Nuclear Reservation was open to private aircraft, as long as one stayed above 2,400 feet. And it seems, in hindsight, that 2,400 feet was the perfect height from which to see the remnants of the old Hanford city site, its empty street grid, and the beautiful curve of the Columbia River.

Hastily built in 1943 to house some thirty thousand workers producing weapons-grade plutonium, Hanford was now a ghost of a town, dismantled and empty.

Leaving Mount Saint Helens and crossing the Cascade Range freed me of the torrential rain, but the sky was still the color of lead. This was perhaps one of the most poisoned landscapes on Earth, and yet in a sudden burst of sunlight and with what seemed an unjustified luminosity, a transcendent light settled over the landscape. I felt then that I was learning an unexpected lesson: our deeper human problems are not the domain of light. Not only does the sun not care about our wishes, but the living presence and beauty of a glorious and luminous light has no enemies. Our shortcomings forgotten, we are all for a moment its children.

Just a few days later, as I was returning east from that trip, another unexpected thing happened. From the window of my commercial flight I saw a multitude of tire tracks in the desert of eastern Oregon converging on a single spot. For a moment I thought I was seeing a missile silo under construction. I am now sure that my intuition was being deceived; there are no ICBM (intercontinental ballistic missile) silos in eastern Oregon. However, the thought of a missile silo made a lasting impression and matched perfectly what was fresh in my mind. Once our minds are open, we recognize our newly discovered interests everywhere.

I returned home looking for answers to unexpected questions I hardly understood. How many bombs do we have? How many missiles? Where are our missiles? How many do we need? How are they made and where? Who and what do these means of destruction really represent? The first thing I did was search at Princeton University's library for maps showing the roughly one thousand in-ground ICBM silos then operational in the United States. The card catalog indicated that such records were in a government publication, but when I went to the shelf, the materials were gone.

To ask for advice more widely, I spoke on the phone with a journalist and antinuclear activist. He said, "I do not know who you are, and do not tell me your name. My line is tapped. All my calls are monitored, and whatever you are calling about, let me just tell you now that whatever you do, it will only get worse for you." His advice was to stay as invisible as I could. I thanked him sincerely, but I thought, "What I am doing is so innocent, nobody will care." Then in the spring of 1986 my department chair passed along his copy of Richard Rhodes's book *The Making of the Atomic Bomb*, and I could not have been more ready.

That summer, my wife, Edith, and I drove to North Dakota, which I knew was home to one of the major missile silo systems in the country. There were missiles in groups A, B, C, D, E, F, and

so on, with a single command station in each flight or group. Each command center, in turn, had ten missiles under its control. At that time, the United States maintained one thousand in-ground ICBM missiles, each with multiple warheads, poised and ready for launching. In trying to find these silos, I learned that a number of local families had driven out on weekends, measuring the rural roads and mapping the ICBM silos. On the East Coast, our university library shelves were missing exactly the books mapping these sites. In the West, local families had produced detailed maps of the missile silos of North Dakota, giving each missile an imaginative or descriptive name and providing directions for getting to its silo.

This appeared to me to be an authentic public response to the distress of having missiles so close to home. In North Dakota, people would say, with a clear sense of pride, "Oh, yes, my uncle has a missile on his property. He just plows right around it. He is still planting wheat, of course, but he also has a missile silo, and he gets rental fees from the government." One also heard: "If North Dakota seceded from the United States, it would be the third largest nuclear power in the world."

By 1988, I had seen and photographed at least a dozen missile silos from the air and read more about the testing in Nevada. That fall I wrote to the Department of Energy, asking for permission to visit the Nevada Test Site and make aerial photographs. These are landscapes about which there is little general awareness, I argued. Both our nuclear testing programs and the reality of ICBM missile fields are all but invisible to ordinary people, especially in the East. With strong support from Princeton University, I received an invitation to visit, but I was not granted access to fly over and photograph the site. However, a two-day ground tour was arranged, allowing a Department of Energy guide to show me some of the largest craters and Frenchman Flat, all of which were treated like showpieces.

During my visit I was shown a photographic laboratory at Base Camp Mercury with a complete Kodak film-processing system in place. Everything was in some way classified. The Department of Energy and the Air Force jointly controlled the lab and airspace. My tour guide was sympathetic to my queries and understood photography. Without any authority to make decisions, however, he could only express his interest and appreciation regarding my desire to make my own photographs from the air. Eventually he made a surprising suggestion. "We've made millions of negatives. Why don't you just print some of ours?" I had done enough aerial photography by then to know what kind of light would be both interesting and revealing, and I knew that government images were usually made at midday. Such images, I realized, could still be revealing and true, in some sense, no matter how low-key the quality of the light. Strangely confident in that moment, I responded, "It's not that these negatives

aren't interesting. A great and useful book could be made with these, but I want to experience this first-hand and to bear witness myself, and if possible find a more articulated quality of light." He responded thoughtfully but also told me that my film would, of necessity, be developed at Mercury. That made me wonder whether the Department of Energy would also want to censor it. At the end of that day, I spoke with one of the senior administrators by phone. It appeared to me that this was my last chance. "Everybody seems to like you," he said, "but I can't grant you access now. It's just not a good time."

I was disappointed. Still, the office staff was as nice as could be. Before I left, someone offered me a set of eight-by-ten-inch press photos. "Don't you want to take some color pictures with you? We give them to everybody." I was given a handful of declassified yet very interesting images. On the back of one was a telling caption: "Yucca Flat, where most nuclear weapons tests are conducted, is dotted with more than 200 subsidence craters from underground explosions." It did not immediately occur to me how deceptive this sentence might be. I could not have known then that two hundred was a fraction of the actual number of tests. Only with the fall of the Berlin Wall in November 1991 and the subsequent détente between Russia and the United States would the record of American nuclear tests be known. In May 1993, the Department of Energy finally published a thorough account of US nuclear tests, from July 1945 through September 1992. The official number of tests conducted by the US government is now said to be 1,054. Even in 1988, it was not widely known that the US atmospheric or aboveground tests alone had numbered over two hundred, one hundred of them in Nevada. The largest detonations occurred in the Pacific, where 106 hydrogen or thermonuclear bombs were tested. Perhaps this is an exaggeration, but it was said then that the Pacific tests released radiation into the Earth's atmosphere equivalent to exploding a Hiroshima-sized bomb each day for twenty-five years.

◆

My interest in making these pictures never diminished. However, I waited eight years, until 1996, to write again and ask for permission to photograph the Nevada Test Site. It took a few months and some interesting twists and turns, but the Department of Energy office staff remembered me, and the public relations officer finally called back with the good news: "Okay, I think I have it set up."

Looking back, I am certain that without a wave of support from many people, especially my colleagues at Princeton University, this moment never would have arrived. There is a small story that I like to tell on myself. On that first morning, approaching the aircraft, I questioned my official Department of Energy observer: "Am I the first outsider or individual given permission to photograph the test site?" I asked because I simply didn't know, and because I could hardly contain a feeling of

exhilaration at crossing an invisible line. The observer stopped for a moment, processing what I'd asked. "Oh, you're not an 'individual,' you're a university." We both shrugged. Feeling completely unschooled or just slow, I made a mental note not to ask that question again.

In December 1996, in order to fly over the Nevada Test Site, one needed to have two official observers in the helicopter, one from the Air Force and another from the Department of Energy. The Air Force observer was a former Vietnam helicopter pilot who could easily have flown the aircraft himself. But while the role of the pilot—a private contractor—was to watch the controls and the skies, the two observers, I soon learned, were there to watch the pilot and me, to make sure neither of us saw anything we weren't supposed to see. The same three people accompanied me on each of my three flights, and they could not have been more helpful, respectful, or professional. With each flight a sense of trust evolved, and with that my confidence grew. Nonetheless, I approached each flight as though it would be my last. I did not want to discount any detail or doubt the importance of any feature of the landscape. Of course, I photographed any landscape that had beautiful light and even some elements that looked quite dull. We could figure out what it all meant later.

Even though I'd seen those official color images from the test site, I was not prepared to understand this unique landscape. From January 27, 1951, until December 9, 1963, one hundred aboveground or atmospheric tests had been conducted at the Nevada Test Site. Many of the devices were mounted on towers, as Trinity, the world's first atomic test, had been in 1945. That detonation took place in the New Mexico desert, changing forever the world in which we live. Here in Nevada, many bombs were also airdropped or suspended from balloons. In almost all these cases, the detonation occurred at an altitude of around one thousand feet, allowing the force of the blast and its shock wave to stay somewhat level or parallel to the ground, increasing its destructive force. Before I knew this, I mistakenly imagined that the aboveground tests would have struck the ground and created craters of the type we see when projectile rockets or bombs land, causing a huge splash of earth and leaving a great scar or crater behind. In fact the aboveground tests often left few visible signs. The extreme heat of some explosions turned the desert sand to glass, or trinitite, but even those blasts left few obvious marks, and still fewer marks remained years after the radioactive debris had been cleared. Underground tests, on the other hand, were usually deeply buried, some as far as five thousand feet below the surface. In such conditions, there is little obvious change on the surface and sometimes no visible crater. However, deep within the Earth a huge volume of rock and soil was simply vaporized, leaving a sphere of space containing nothing but radioactive dust and debris. Often, the Earth's crust convulsed from the explosion and bulged up before

slumping back, sometimes hours or even days later, into the void left by the nuclear explosion. That is a subsidence crater. The films of this moment are truly unsettling, terrifying. These bowl-shaped, concave forms are the residual visual evidence of the greatest number of nuclear explosions at the Nevada Test Site, and they make this landscape like no other on our planet.

I didn't know it then, but the secret or infamous Area 51 was only one mountain ridge away from the northern end of Yucca Flat. In 1996, the existence of Area 51 was still not openly acknowledged by our government. While in the air, the observer from the Department of Energy must have been keenly conscious of this. Whenever we came close to the northern end of Yucca Flat, he'd say, "Now you've got to look straight down. No looking around." The Department of Energy observer watched me, and the Air Force observer watched the pilot, repeating, "Straight down."

From the beginning, I expected that the Christmas 1996 flight would be my only flight. Later, however, in follow-up discussions with the Department of Energy public relations officer, I said, "You've seen what I'm doing, and I think you understand my desire to make a faithful record. Will you help me identify the specific locations and contents of a dozen pictures? And may we ask for another flight next year?" He said he would do his best.

Although I always think of my response to the site as fundamentally visual and guided by feeling, I also wanted to know the name of this or that test, whatever it was, and even its series, if possible. This information grounded my experience and helped me relate the testing and its history to our own place in time: this test took place on a particular day with a particular yield. It may not seem personal, but every day is also someone's birthday, and for someone else, a wedding day. If our lives were made "safer" by these tests, then the business of life still mattered, just as the smallest particulars always matter.

Soon I sent the first group of prints to the main office. A month went by. I was anxious to get the results. I called the office and explained who I was, and the woman on the line said, "Oh, the ladies in the office all say these are the best pictures ever made here." And it was the office ladies who gave me the feeling that I should ask to return. It was as if the situation had completely changed. When my call was returned, the public relations officer said, in essence, "We'd like to have you come back."

By the following year, when the Air Force again had its Christmas break, I had a better mental map of the landscape. And for these flights I also found a second gyroscopic stabilizer, almost a necessity for neutralizing the vibrations of an aircraft in flight. Now, if one camera ran out of film, I could grab another that might still have film in it. I was photographing with three cameras, almost as constantly as humanly possible and with gratitude for those two stabilizers. There was something astonish-

ing almost every minute. Once I frightened myself and my observer as I shifted a bit too quickly from one side of the aircraft to the other. Both doors had been removed to improve our field of view and image clarity, so that only air and atmosphere separated us from the desert below.

In December 1997 I was able to make two separate flights. A winter storm shut down our first attempt, but a week later we found good weather and saw many things that were new to me, including the location of a tall-tower atmospheric test dated August 31, 1957, called Smoky (plate 29). My Department of Energy observer pointed out the spot as we flew near. While the spot itself was rather nondescript, something in the way he identified it signaled that something significant had happened here. Smoky, I later learned, is still considered radioactive and is strictly avoided. The test involved as many as seven hundred troops, some of whom marched as near as three hundred feet from the tower's melted remains at ground zero. The Center for Land Use Interpretation, in *The Nevada Test Site: A Guide to America's Nuclear Proving Ground*, states, "The soldiers were later proven to have been severely irradiated in the test." And of course the radioactive cloud behaved as clouds will, drifting both north and east.

Years before, a pilot with whom I worked in Washington State, and whom I greatly respected, said that as a teen he often flew officials from the Department of Energy up over the Hanford Nuclear Reservation in a little Cessna. His story may be only one of many, but it preserves a glimpse into an otherwise less than visible world. He told me that he was often amazed by the conversations he overheard, in part because they took place as if, perhaps because of his youth, he didn't exist.

One mind-bending story was about a batch of Eastman Kodak X-ray film that was worth, perhaps, millions of dollars. As soon as the film was made, it was tested and found to be mysteriously spoiled from exposure. This batch of film, even after repeated testing, proved a total loss. In trying to discover what had happened, Kodak eventually approached the Department of Energy and asked, "Is there any way that radioactivity from one of your tests could have reached the eastern United States? Could radioactivity released into the atmosphere reach the southeast?" In the pilot's story, that's what seems to have happened. Radioactive dust and debris from Nevada had entered the jet stream and been carried east over the American South. A rainstorm dumped that radiation onto cotton fields. When the cotton was picked, carried to Rochester, turned into cellulose acetate (film base), and coated with X-ray emulsion, it was sufficiently radioactive to expose and ruin the freshly coated film.

I had no date for this event, but people in the Department of Energy with whom I spoke in 1996 confirmed that at least the fundamental story was true. Another version of the story suggests that at least one instance of spoiled X-ray film may have occurred immediately after Trinity, the first test of

a nuclear weapon. That first atomic bomb was exploded in New Mexico's Jornada del Muerto desert at 5:29 a.m. on July 16, 1945. That experience prompted J. Robert Oppenheimer to quote the Bhagavad Gita: "I am become death, the destroyer of worlds."

It may not take a lot of radioactivity to expose X-ray film, but that's not the point. This story illustrates a deeper reality: over decades, the effects of testing were not contained within Nevada or anywhere else nuclear weapons were used. Radioactive dust from over two hundred aboveground tests was crossing the continent every which way from 1945 to 1957. Even underground tests "vented," allowing radioactive material to escape into the atmosphere and encircle the Earth.

Eventually, the flights and images began to weigh on me in another way. Slowly I began to understand how a thousand tests looked and felt, and I knew it was time to stop. I began to feel a profound sense of dread and remorse. How much did it cost to do all these things? And in what ways are we still paying?

The largest crater at the Nevada Test Site, 1,280 feet in diameter, is called Sedan, in Area 10 (plates 25 and 33). Unlike other underground tests in which devices were buried thousands of feet deep, at Sedan the device was detonated only 635 feet below the surface, in order to demonstrate how much earth could be moved with one explosion. Though not an exceptionally large device, Sedan was a thermonuclear test, combining fission and fusion. It was said to be similar in yield—104 kilotons—to the warhead of a Minuteman I missile. It certainly feels strange, or like a misdirection, to say that the Sedan test was conducted to find a peaceful use for nuclear weapons.

On January 3, 1993, a treaty known as START II (Strategic Arms Reduction Treaty) between the United States and Russia signaled the beginning of the end of nuclear testing. Divider was the name of the last US nuclear test, conducted on September 23, 1992. The Icecap test, planned for later that year, was to be a joint underground nuclear test, cosponsored by the United Kingdom and the United States. The Icecap site is unique in that the tower for shaft drilling and assembly remains in place, along with trailers and fiber-optic cables (plate 18). As a gesture of goodwill during the negotiations of START II, the United States ceased actively testing, but this is a moratorium and not part of a permanent treaty. There is nothing to stop the United States from restarting nuclear testing. It is also important to remember that the Comprehensive Test Ban Treaty (CTBT) has never been ratified by the US Congress.

By the time the last tests scheduled for Nevada were canceled in 1992, the United States had conducted more nuclear tests than all other countries combined.

◆

Revisiting these images decades later feels much like looking back twenty years after your parents die. You've settled into a new reality. That old reality can no longer be changed. You are no longer in remorse about their deaths, but rather preparing for your own, and wanting to put your house in order. It is in this spirit that I came back to these images with some renewed optimism. In 1997, when I last photographed at the Nevada Test Site, the world seemed to have changed. I had a hope that we might outgrow our dependence on nuclear weapons and our affection for war. But I was not free of the nagging feeling that perhaps we would never change. Clearly, this book was a responsibility I had postponed. Now I think that, having been given the opportunity to be a witness, I would have been sad for the rest of my life if I had not taken these images seriously. If I had thought, "This is not my subject," I would have come to feel disrespectful of reality. The very tone of this thought reminds me of my old friend the philosopher-artist-photographer Frederick Sommer, now passed, who liked to say, "The important thing is quality of attention span and to use it for acceptance and not for negation."

◆

On my first visit to the Nevada Test Site in 1988, there was an hour or so when I was alone walking on the vast expanse of Frenchman Flat. My Department of Energy guide had been on the flat too often in the past to expose herself to it again unnecessarily. Besides, on the ground, Frenchman Flat really is desolate. In spite of the weight of history, it can feel almost empty. That day there was a profound silence to match the thin gray weather. Yellow boundary tapes indicated where one must not walk, but otherwise I was free to wander. I carried my camera but made few pictures. I was walking at random, trying to imagine the long history of this place, this landscape, when my sense of solitude was broken by the sound of an animal running.

Faint at first, the pace of footfalls was frantic, full out, and then the cause came into view: jackrabbit. Huge, larger than I imagined possible, and in full tilt until it saw me. Its long ears, which had been folded down low across its back for speed, came up, and its pace slowed noticeably, but only for a few short strides. Now the ears went full down against its back and the jackrabbit returned to full speed. Then it was gone. Something of a small miracle and so close, no more than ten or fifteen yards away from where I was standing. Only a few seconds later another set of frantic strides became audible, and almost instantly, there he was. Coyote. I don't think he ever saw me or even sensed my presence. His pace never changed. His mind seemed to be on just one thing.

◆

The Earth is always in motion, always changing, and yet we can still experience the feeling of stillness. Even when the landscape is gravely brutalized or disfigured, it is always deeply animated from within.

FEBRUARY 2019

PLATE 67

LOOKING EAST FROM YUCCA LAKE TOWARD PLUTONIUM VALLEY, NEVADA TEST SITE, 1997

The valley takes its name, at least in part, from the four-part Project 56 Plutonium Dispersal Safety Tests, conducted between November 1, 1955, and January 18, 1956. The first three tests were considered successful; however, the fourth test is said to have failed and a large area still contains dangerous amounts of raw plutonium scattered by those dispersal tests.
Plutonium Valley is considered to be the most heavily contaminated area of the Nevada Test Site.

36°58'27.57" N 115°59'43.63" W

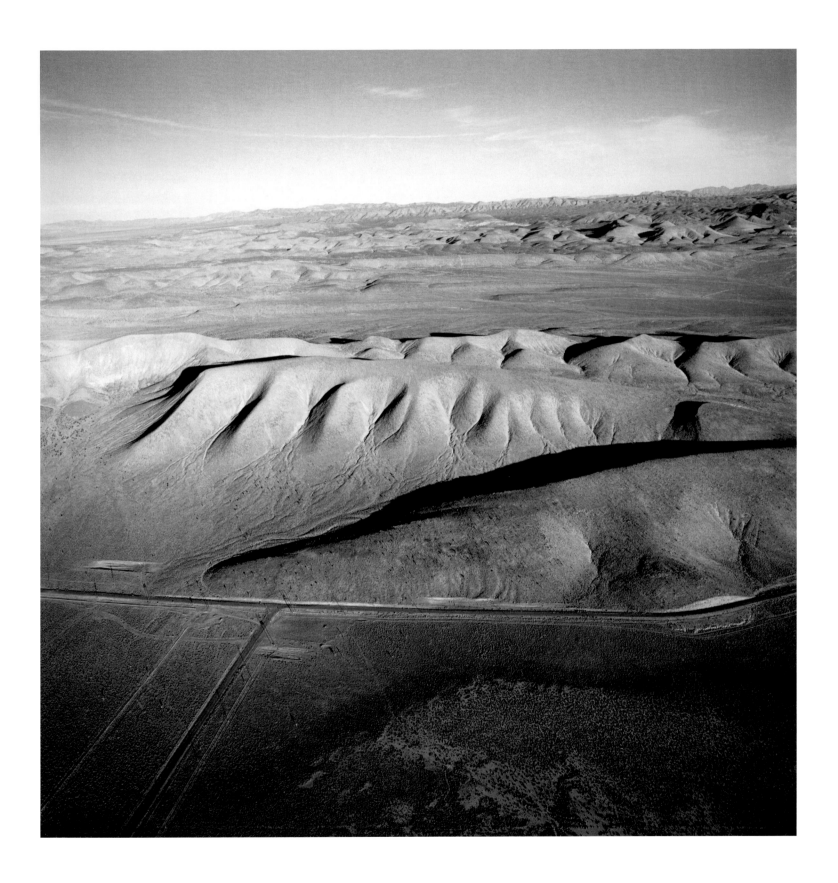

REFERENCES

The following sources provided factual information included in the text and captions. I am also grateful to Michael D. Gordin, Rosengarten Professor of Modern and Contemporary History at Princeton University, for his assistance. Any errors in the text are my own.

Coolidge, Matthew. *The Nevada Test Site: A Guide to America's Nuclear Proving Ground*. Los Angeles: Center for Land Use Interpretation, 1996.

Day, Samuel H. *Nuclear Heartland: A Guide to the 1,000 Missile Silos of the United States*. Madison, WI: Progressive Foundation, 1988.

Department of Energy. *United States Nuclear Tests, July 1945 through September 1992*. DOE/NV-209 (Rev. 14). Washington, DC: US Government Printing Office, December 1994.

Sommer, Frederick. Television interview. *AM Philadelphia*, May 1980.

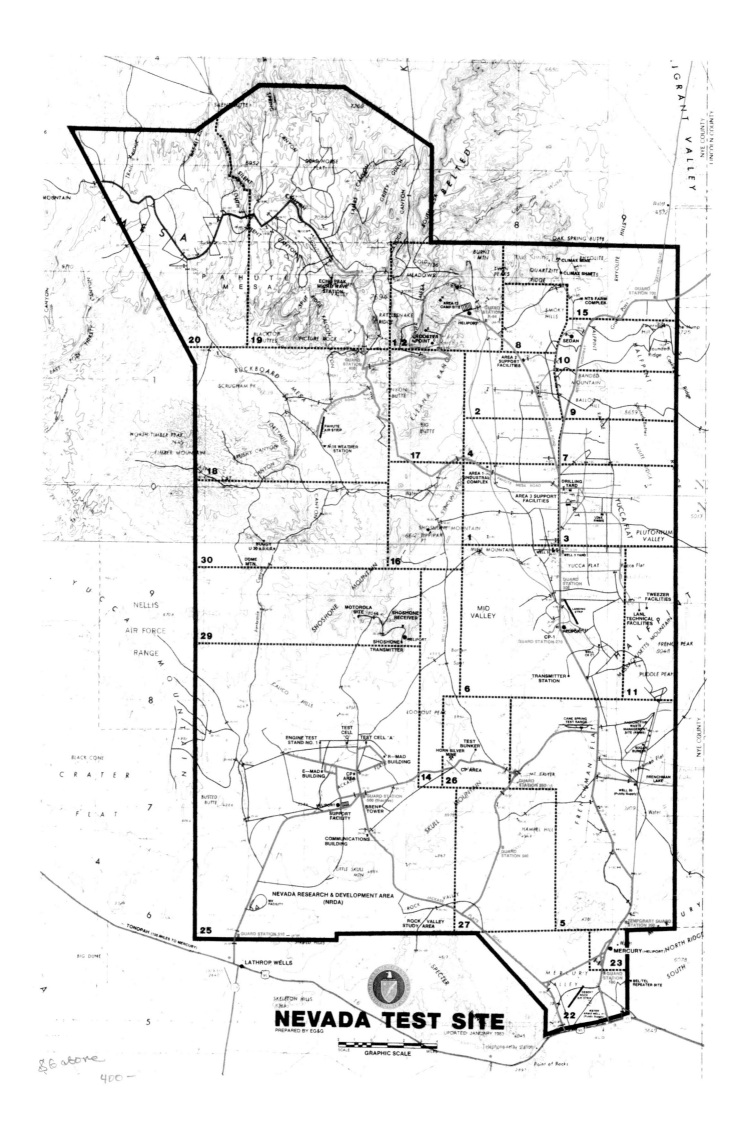

NEVADA TEST SITE

PREPARED BY EG&G

UPDATED JANUARY 1983

GRAPHIC SCALE

Within Google Earth is a gallery section, and within that gallery is a pull-down tab called Google Earth Community. This is where the detailed information on test names and their dates can be found. Almost every crater is identified at least twice by different individuals or sources. Markers on the map lead to notes that give the details of test names, dates, and even times and yields, and are almost always in agreement. Because of the more than twenty-five identifications I already held from the Department of Energy, dating from after my 1996 flight, I could confirm the accuracy of those names and thus was comfortable in accepting the accuracy of the Google Earth Community identifications. I was also able to cross-reference test names with the Department of Energy's own published list of tests. This is to say that I believed I could trust these Google Earth Community identifications. I suspect, but can't confirm, that former or retired DOE workers may have done much of this work. Needless to say, until the government publishes its own guide to the Nevada Test Site, this is the best source for this information that we have.

COORDINATED BY MICHELLE KOMIE, STEVEN SEARS, AND MARK BELLIS

DESIGNED AND TYPESET IN CENTAUR TYPES BY KATY HOMANS

DIGITAL SEPARATIONS BY ROBERT J. HENNESSEY

PRINTED BY TRIFOLIO PRINTING UNDER THE SUPERVISION OF MASSIMO TONOLLI